The Good, The Bad and The Ugly

the good, the bad + the ugly

ATELIER VAN LIESHOUT

N
6494
.P66
A8413
1998

CONTENTS

6 **Drs. M. J. Noordervliet**
JOEP VAN LIESHOUT: A DEPTH PSYCHOLOGICAL PORTRAIT
Life task - Survival strategy - Tantra and Priapus - Inner freedom - The Bio-prick - Love and conflicts - The Good, The Bad and The Ugly - Absent father - Indecision - Sex and friendship - Romanticism and danger - Charm, aggression and spirituality - Armed to the teeth - Ultimate safety - Paradise and womb - The philosopher's stone - Explosion or transformation - Sensitivity - Pure forms as shadow

28 **Prof. dr. P. J. Hoefnagels**
THE GOOD, THE BAD AND THE UGLY
Self-sufficiency - The logic of the artist - The constitutional state - The law of the jungle - Violence and counter-violence - Taking the law into your own hands - Fifty years on

52 **BelBin Associates**
TEAM ROLE COMBINATIONS REPORT
SPI + OBSERVER DATA

65 **IMAGES**
98 **CAPTIONS**

100 **Ir. B. O. Lootsma**
THE GOOD, THE BAD AND THE UGLY OR:
SYMPATHY FOR THE DEVIL
Cowboys and Samurai - Spaghetti Westerns - Counterculture - Ambivalences - The legacy of the sixties - Periphery and autocracy - The devil's advocate - Individualization - Hold on and let go - Free zones

120 **BIOGRAPHIES**
124 **COLOPHON**

Menno Noordervliet

JOEP VAN LIESHOUT: A DEPTH PSYCHOLOGICAL PORTRAIT

The life of the artist Joep van Lieshout - his personality, his activities and their significance - can be seen as a story that has yet to be unveiled, one part of which has already manifested itself, while the other still lies in the future. His artistic creations also form part of this story, even though they have taken on a life of their own.

Life task

Because Van Lieshout as a person has been formed by psychic processes which defy scientific explanations, it is impossible to know what really makes him tick. The best way of establishing who Joep van Lieshout really is, is by looking at it as a story. Depth psychology, including astrology and bio-energetics, provide the entry points. Astrology gives an in-depth explanation of Van Lieshout's life process: the development and interaction between what has already happened and what is still to come.

His horoscope - a blueprint of what he is and what he will unfold - immediately reveals an area of conflict. What his life will unfold is: collaboration, collegiality and partnership above conflict, personal interest and polarities. You could call this his own, utterly specific life task. It is a theme that manifests itself in everything he does, that runs through everything, although it is not easy for him to put it into practice.

Survival strategy

No one comes into this world an empty book. The seeds of each person's unique characteristics are already present. Joep van Lieshout came into this world extremely well-versed in interpersonal contact and social networking. Even as a child he knew where that could go wrong. These insights were not fostered at home because that was not his parents' culture.

He takes refuge in a survival strategy, aimed at creating and engendering forms; a multitude of forms are born. This generates tremendous energy and that is what he presents to the world.

The area of conflict arises out of the fact that, on a spiritual level, Van Lieshout is unconsciously aware that his life task is to rise above these polarities. His survival urge prompts him to dedicate himself to creating abundance. He creates an abundance of material forms, falls frequently in love and enters into many relationships with women, whereby he demonstrates his power.

Tantra and Priapus

On the other hand there is a strong tantra element in Van Lieshout. This is the inner conviction that opposing forces are transformed by surrender, instead of the idea that something should be conquered by control and force.

However, as an extension of the tantric potential, Van Lieshout also reveals a converse tendency: the need for a sexual power display as survival strategy.

This is the Priapus force which in Van Lieshout's case is in opposition to his tantrism. Priapus is the god with a permanently erect phallus, always ready to copulate and ever fertile. A hedonist who indulges his own lusts. Priapus knows nothing of surrender: he takes what he can, where and whenever the opportunity arises.

On the surface, a man who has a harem at his disposal enjoys the greatest freedom. Van Lieshout makes no attempt to deny that he is fond of women or that he gives full rein to his need for sexual intoxication. He associates it with his yearning for freedom. Essentially a Don Juan is manly and fearless. But also a slave, a prisoner to his desires, in a state of inner bondage.

Inner freedom

According to the tantric tradition, sex energy - in contrast to the energy of Priapus - is a life-giving force that leads to true inner freedom. Anyone wishing to understand its secret must develop insight and consciousness. He must learn to understand the language of his innermost being, his source. This lies largely in the unconscious, where the self that depth psychology speaks of manifests itself. The self crosses the boundaries of the limited ego. It is bound up with the total existence, it is timeless, it knows no polarities. One's life task is on that level.

The self is not objectively perceptible, it has to be experienced. This experience can be expanded by attention, forms of meditation for instance. And sex can serve as a vehicle for tapping into this source, the self. The tantric tradition has developed meditative sex to the most subtle levels. In essence tantra is not so much a mode of behaviour, but more an inner attitude.

The Bioprick

Meanwhile the prominent Priapus force has led Van Lieshout to create the 'Bioprick'.

This mega-phallus is a materialized projection of the urges which Priapus embodies. There is nothing secretive or monstrous about it. Despite the spiritual challenge that his horoscope sets him, Van Lieshout has no affinity with either religion, ritual or the numinous.

The Swiss psychiatrist Carl Jung ascribed divine powers to a giant swollen phallus situated in an underground temple, which appeared to him in a dream vision. He interpreted this manifestation as a secret god who is ineffable. But with Van Lieshout everything is overt and worldly.

Nearly a hundred years divide Jung from Van Lieshout, yet both men are exponents of their time.

Love and conflicts

To get back to the opposing forces in Van Lieshout's horo-scope. The basic polarity already mentioned brings with it a string of other, associated polarities.

On the one hand his life task consists in developing the spiritual, synergetic forms of collaboration, in attuning himself to others, in deepening interpersonal relations. On the other he has a fascination for power and sexuality, he exploits relationships, is addicted to lust and intoxicat-ing experiences and Dionysian ecstasy, which only serves his own ends. Although he works as part of a team at Ate-lier van Lieshout, he is the boss.

He describes himself as being calculating and says he is capable of committing murder. Machiavelli, a master of unscrupulous power politics and ruthless manipulation, is a favourite author. Furthermore Van Lieshout is driven to realize certain power manifestations through his art, as reflected in some of his recent work, such as 'Mercedes with 57mm Canon' and 'Workshop for Weapons and Bombs'.

But at the same time he is eager to discuss any conflicts at work and is upset when they cannot be redressed and resolved. He would rather avoid them altogether. Like all Libras he wants people to like him. With Venus in Libra he is extremely susceptible to love and harmony.

The Good, The Bad and The Ugly

How is one to reconcile this urge for harmony with the insatiable beast in him? Because he likes to act the beast, it mobilizes his energy. In fact the beast in him is his ener-gy reservoir. He is sometimes deliberately reckless and courts danger. And he uses his energy to continually break down his boundaries. That is the fighter in him, the aggressor, which stems from the survivor. And because he focuses on his survival strategy his ego tends to go into an inflationary spiral.

In short: 'The Good, The Bad and The Ugly' - the title of Atelier van Lieshout's show in the south of France in summer 1998 - seems effortlessly united in one person. Effortlessly? That's the question.

Before answering this question let us go back to our earlier observation that Van Lieshout is worldly. All his work is functional and ready to use. In that sense his work is also highly communicative, it is geared to the relationship with the environment.

Like most men Van Lieshout loves material objects. And he seems to derive his inspiration more from that than from the spirit. Symbolically speaking the spiritual world is linked to the Father, while the material world is connected to the earth, to the Mother: mater is the Latin for mother.

In this sense our entire Western culture suffers from an Oedipus complex. Oedipus, without realizing it, killed his father and married his mother. The Oedipus complex symbolizes the unconscious, powerful link with the mother. In our society materialism reigns supreme and to a certain extent we have declared God, the Father, to be dead. Jung believed that we have not really renounced our unconscious, psychological incest wish.

Absent father

Looking at Van Lieshout in this context, we see striking parallels between his development as a person and an artist, and his relationship with the maternal, the female, starting with his own mother with whom he has a deep bond.

Van Lieshout's father died when he was nine, too young to have been able to measure up to him as an adolescent and nascent adult. As a result he developed an intense bond with his mother. He has a deep and unassailable conviction that he loves her. The bond of love is mutual.

His mother reveres him.

Van Lieshout's mother probably saw the young boy as a replacement figure for his father. In addition to a sister there was also a brother, eight years older, but he left home early on. His mother probably shared her problems and worries with her youngest son when he was far too young to deal with them.

People who are caught in such a situation usually remember very little or nothing of it. Particularly in families where emotions are never talked about openly, as was the case in the Van Lieshout household. The feeling was there, but it was suppressed.

Emotional events like death and separation from family members set off a whole train of unconscious processes, which often prove formative in later life. An awakening consciousness can free one from an old emotional burden, whose precise content had been forgotten.

According to Wilhelm Reich and Alexander Lowen (bio-energetics) a phallic-narcissistic character structure can develop if the father is absent and the son assumes the role of the man in the family long before he is able to cope with it.

Phallic in terms of the importance of the phallus as a symbol of aggressive, competitive behaviour. This is where Priapus re-enters the picture. Narcissistic because visible achievements and outward show take the upper hand. For Van Lieshout, his achievements and demonstration of success are important yardsticks against which to measure his self-esteem. But the danger of this predilection for show is that it makes him dependent on it and deflects him from his true task.

Indecision

Van Lieshout's early family life has unconsciously made him feel that he continually has to live up to an ideal of

manliness. The result is that he oscillates between a superiority and an inferiority complex. Generally speaking, in his case, this has led to indecision when having to make choices.

He himself does not see this as a negative aspect. Survivors like himself suffer from profound indecision in order to come to one rapid moment of decision which produces major ideas and important new steps. Indecision when confronted with various possibilities is also characteristic of a Libra.

On a deeper level - unconsciously - there is some doubt whether he was accepted by his father and mother. This brings into play intense feelings of hurt and an overwhelming need for tender and loving contact. On a conscious level it is not usually experienced like that, but nevertheless this is someone with a highly developed instinct and a certain vulnerability. Van Lieshout is exceptionally sensitive and intuitive. He cannot bear to lose people, to lose touch with friends. This is where he is vulnerable.

Sex and friendship

Total surrender to a woman fills Van Lieshout with fear. He likes to conquer women but is afraid (and refuses) to fall for them. He sees it as a failing that, for him, a woman is just one of many, whereas she might see him as the only man in her life. In fact he cannot get through a single day without a woman - he does not like being alone. Yet he rejects permanent and exclusive relationships because, for him, they cancel out sexuality.

He is quite open about not being monogamous. He turns his love affairs and sexual relationships with women into friendships. Indeed his friends are women, and he makes no distinction between friendship and sex. In order to satisfy his emotional needs he demands endless attention from his friends.

His libido is inexhaustible in relationships that have been left open and are, therefore, devoid of any feeling of expectation or definite commitment. This type of relationship can last for years, but as soon as Van Lieshout makes a formal commitment to a woman it immediately becomes a negative experience for him, and this is undoubtedly bound up with his relationship with his mother. It is as though the form weighs too heavily, which in turn blocks off the flow of tantric sexual energy.

Van Lieshout's horoscope indicates that in the end he will experience sexuality in a pure, natural manner.

Romanticism and danger

His sundegree, the point in a horoscope that also determines how a person's character will be formed - shows the romantic image of a man and a woman climbing a cliff together. The cliff is being washed by the sea. Sea - water - symbolizes the instinctive element, but also drowning in the infinite.

The man and the woman climb up the stony path to the top. The steep path winding along the cliff indicates ample opportunities for social climbing. But it is a dangerous undertaking. The man wants to help the woman climb up and he holds out his hand to prevent her from falling. But in so doing he stumbles himself, and as he slips he is in danger of falling down to the bottom. At that moment a ring and the links of a chain - symbols of attachment - fall into the sea. The image indicates an imminent fall, which of course must be seen and taken figuratively. It is a force that operates in the background, but is in some way or other influential. That is to say that a fall or decline - moral or physical - is potentially always present in a relationship. It alludes to the danger that inconsequence can make or break relationships. Another aspect is that - as in the story of Samson and Delilah - a woman can strip a man of his

power. The image also emphasizes the positive possibility that the man and the woman can be a support to one another other and help each other not to fall. It can also indicate an exciting tension between the sexes. The archetype warns Van Lieshout to be vigilant in relationships.

Charm, aggression and spirituality

Van Lieshout's sign Libra is heavily bound up with the relationship aspect. He is extremely open and spontaneous in relationships and his charm allows him to get on well with many different types of people; he can also work with them. There are a great many relationships.

The social mask of friendliness that he quite naturally presents to the outside world, conceals the latent aggression in him. He feels a strong connection with art, beauty and love. He is also keen to make a good impression on others, eager to please them and adapt socially for their sake. This duality is also manifested in his work: his hand-jewellery that is primarily intended to enhance a person's looks, turns into weapons, his art would seem to be highly dangerous; behind the beauty and charm lurks aggression. Here we see his Mars in Scorpio.

The question of whether Van Lieshout effortlessly unites 'The Good, The Bad and The Ugly' in himself still has no clear answer. Effortlessly perhaps, in so far as Venus in Libra and Mars in Scorpio, respectively, channel his feeling for beauty and his strong aggression into pure, authentic experiences.

But the polarities in his character can also work against him. A positive use of his potential, whereby the opposing forces are meaningfully resolved on a spiritual level, is not easy. His horoscope shows that in later life his spiritual tendency will take on a greater role.

Armed to the teeth

For Van Lieshout, trying to integrate these polarities is certainly not effortless. He probably suffered some traumatic experience before he was born, that is before his ego developed. This accounts for his power-related urge to show that he, alone, among the rest of the world, will be able to survive.

Maybe he experienced a life-threatening situation when he was still in the womb which later prompted him to create the survival unit 'Autocrat', symbolizing the womb. Its inhabitant is armed to the teeth so as to be able to fight his way through life and end by finally creating the utopia of freedom, sovereignty and heroism. But his compulsion for isolation, stemming from his survival strategy, brings him unwittingly into conflict with his essential need for contact.

Ultimate safety

According to Lowen's typification a prenatal trauma is the cause of a schizophrenic character-structure. The trauma brings the person into conflict with his life course. In Van Lieshout's case the tantric life course has been interrupted by a narcissistic-priapic tendency.

The effects of prenatal trauma are such that it requires considerable energy to keep yourself together, so to speak. All experiences that take place before the development of ego are no longer accessible on the surface, but lie buried in the soul. And they can only be resolved on an archetypal level.

Van Lieshout's life is dominated by two archetypes: the penis (which we have already discussed) and the womb; both are formative to his work.

The womb comes in a variety of forms, such as the skull-rooms, the so-called 'Sensory Deprivation Chambers' and mobile homes which form a soft, enclosed world in which

people can lead an autarkic life. These are practical, usable imitations of the womb which also cater to a foetus's every need.

Moreover the womb represents the complete absence of negativity, of anything that could be experienced as unpleasant. In short: paradise, the symbol of ultimate safety. There is a clear parallel to be seen here between Van Lieshout's work as an artist and the theme of safety that looms large in his own private life. This longing for safety is also reflected in the importance that he attaches to his home. Going abroad is a vital part of his work, but he is never away from home for more than two weeks. For him, his home situation is a safe haven from which to venture into the outside world.

Paradise and womb

The universal image that people have of paradise undoubtedly springs from their pre-conscious memory of the womb from which they were driven like Adam and Eve out of the Garden of Eden. The exhilaration, the Dionysian ecstasy, the intoxication of sex addiction lie in the unconscious memory close to the intoxicating oceanic state of one's time in the womb. An experience which Van Lieshout, seemingly driven by an unknown longing, gladly repeats.

But there is one important difference. In place of the womb creating him, he creates wombs that function according to his will and perception. And now instead of simply being the creation of a penis, he is also the creator of penises. In this he is affirming his power, equating it, as it were, with the power of the Creator. According to the psychoanalyst Otto Rank the root of all art lies in the plastic imitation of the womb.

Initially primitive man created a vessel for storing or hiding things in. In later art this vessel developed into a rep-

resentation of, for example, a head, and finally into a reproduction of a complete human being. Rank argues that when an artist creates forms in his own likeness or in the image of the womb, he is repeatedly reliving the events of his birth. In so doing he tries to allay and conquer his primal fear of the trauma of birth and separation from the mother.

The philosopher's stone

The artist's identification with the bestower of life - the mother or the Creator - recalls the workings of medieval alchemists.

The alchemists created a container, a hermetically sealed vessel in which metals were melted down and mixed. This vessel, like a womb, also symbolized the intellectual concept in which a chemical, biological and psychic process could take place. This eventually led to the 'elixir of life' or to new forms of life of a higher level. Alchemy was creative art, the alchemist was a seeker of the philosopher's stone, a magician, an adept in bringing out transmutation processes. Van Lieshout does not consciously engage in transmutation and in his emphasis on the functionality in his work, he masks its irrational aspect. But for the initiated there are sufficient allusions to the symbolic value, which he has managed in a magical way to give back to everyday practical objects.

Explosion or transformation

Explosives play a part in Van Lieshout's work, just as they did in the alchemists' workshops. Mercury in Virgo points to a strong, investigative urge that was already present in him as a child. At that time he wanted to become a scientist or an artist and experimented with improvised laboratory situations. So when the neighbours heard a bang they knew what he was up to. Now when he is working on

the idea of making bombs, he is in fact projecting, as it were, his explosive inner force with all its aggression onto the outside world. Pluto and Uranus in Virgo point to this. For the alchemists there was also a danger that their experiments might lead to explosions, as the heat attained during the alchemical process is highly explosive. But if the metals are melted with sufficient caution then the opposing elements melt at the point of fusion into a new alloy, a new quality. That is transmutation.

These images are not to be taken literally; the language of inner work has its own metaphors.

Inner work is always servant to the life task. But as Van Lieshout becomes increasingly out of touch with his source or his innermost potential and his life task, he will become more and more a slave to his survival strategy. Then he will instigate conflict and play the ringleader in order to stay on top. The danger here is that his inner urge to make art founders in aggression. Then the urge to be an artist is not for the sake of art itself, but for the notable self-image it brings, the glittering success and the power, which like sex, is addictive. That tendency is, as it were, an inner dragon that he must slay.

Sensitivity

Van Lieshout's fascination with power and sexuality is his sensitive point. And it is along this path that he will achieve realization and liberation, by which I mean that it is these aspects that will confront him most deeply, because this is the area that hurts him. That is why he often goes out of his way to avoid it.

The transformation of his need for power could lead to communication, social contact and teamwork. But it is precisely his longing for perfect communication, for merging with another and for the oceanic womb experience that makes him vulnerable. His sexuality could be

transformed into tantric energy - but that too is a highly sensitive area.

In his horoscope Chiron - the mythical centaur-archer and teacher of all heroes - marks his vulnerable point. Chiron operates in the sphere of communication. Van Lieshout's macho behaviour can be seen as an overcompensation for his exceptional sensitivity to power and sex. In terms of depth psychology his art can be seen as a healing process: his work serves to heal his wound from his pain.

Pure forms as shadow

Personally and socially, the creative road that Van Lieshout has embarked on is utterly unique and exceptional.

With Sagittarius in the ascendant he is driven by a huge dynamism, and he achieves an enormous amount in a short space of time. The ascendant represents the way in which someone presents themselves to the outside world. Jupiter in Aries provides abundant energy and exuberance and gives Van Lieshout's character a fiery or choleric nature. He is able to tap into a strong formative power. And he has the talent to mould ideas and inspirations rapidly into a form. Moreover when he is in the grips of a creative process a flood of information and energy flows through him. He throws his whole being into this process. And he sees the outside world's misunderstanding as a challenge he is all the more determined to take up. He sees repetition as a form of ossification. This drives him to constantly seek new and vital forms, and as we have already observed this is part and parcel of his survival strategy. But the inherent danger in this is that he can become obsessed with pure forms. And as I have already said, this also reflects the Don Juan in him: lurching from one love affair to the next is another manifestation of his obsession with outward forms.

The danger of patterns becoming ossified can also exist on the inner, psychological plane. For Van Lieshout, breaking through these forms represents an essential challenge and has to do with his life task. It also allows him to break down boundaries on an inner level, whereby he acquires energy for new forms manifested in terms of new insights into himself. He can then come to recognize his shadow side, the aspect of oneself that one never accepts and therefore keeps locked in the unconscious. The more one denies one's shadow side the more one projects it onto the outside world. A good example of this is his own hidden female side. Every man has this side in him and he projects this onto the women he falls in love with.

Carl Jung called the inner woman the anima; when a man recognizes her in himself she can become a good guide.

Peter Hoefnagels

THE GOOD, THE BAD + THE UGLY

'An uzi was propped up against the draining-board'

Self-sufficiency

When asked to write an introduction to the exhibition 'The Good, The Bad and The Ugly' (Atelier van Lieshout stipulated that it had to be about 'the content', not art), I sought out the catalogue of Joep van Lieshout's previous show in the Museum Boijmans Van Beuningen and the Cologne Kunstverein ('Atelier van Lieshout, A Manual'), as well as a few of his sketches. I like architects' and designers' sketches, particularly if they've been drawn freehand, unassumingly and unpretentiously. Sketches like that give us an insight into how they see life.

One of the drawings depicts a cosy scene on a piece of land with scantily dressed women, a cow and a couple of pigs, all gathered round a mobile home which I take to be Van Lieshout's 'Autocrat'.

In a second sketch we see a spacious kitchen with three women standing round a table preparing food, a vital interaction between a box of vegetables, a box of potatoes and, casually propped up against the draining-board, an uzi - at any rate an automatic weapon with a large magazine - somewhere near the outside door. Just in case one of the women might need to use it in self-defence. Or would Van Lieshout himself rush to their aid? That's more likely because the women are concentrating on the meal.

A third drawing shows the living-cum-bedroom with Van Lieshout's amply proportioned bed, well sort of bed: it's more a comfortable nest in the room where sleeping is certainly not the only activity that men and women can engage in.

The first three drawings give us an idea, which we recognize from earlier work, of Atelier van Lieshout's concept

of a self-sufficient community. It instinctively reminds me of the commune set up by the romantic doctor and writer Frederik van Eeden at the beginning of this century. Situated in 't Gooi in Holland his community, which was called Walden, was also pervaded by a sense of freedom, peace and vitality. Walden was to be a better place than anywhere else in the world. The same could be said of Monte Veritá in Ascona, which attracted many artists, theosophists, anthroposophists, nudists and many other alternative fortune-hunters and ideologists. But this is where the comparison with Van Lieshout's autonomous community ends because his approach is much more practical and functional, with well-conceived designs and modern comforts, while sex and the desire for it - call is eros - is also much in evidence.

Van Lieshout has no truck with any ideology. But many people are hooked on ideology and there's no knowing how they can twist an artist's ideas. People lurch from one lunacy to the other, distorting one's intentions with the most dangerous rubbish. An uzi was propped up against the draining-board. The new developments at Atelier van Lieshout will certainly ring alarm bells, as we shall see. Not for Van Lieshout and his kind, but for the others. "L'enfer, c'est les autres". Ideology and weapons is an explosive combination. Since 'Walden' and 'Monte Veritá', the society around their idyll has changed; whatever else, it's become more threatening.

An overview drawing depicts a house near a factory with trees, a watermill and a small bridge, all securely enclosed by watchtowers that can certainly serve as shooting posts. There's also a tank at the ready in the grounds. The idyll is well-protected against malevolent intruders. The assumption is that the good are inside and the villains outside.

The fifth drawing provides an overview of the grounds

with texts written on the buildings. 'Atelier van Lieshout' is large, there are obviously quite a few people hard at work there. Next to the kitchen there's a 'communal area', a 'dormitory', a 'farm with stables' - the self-sufficiency is carried rigorously through - a 'log-cabin' and 'Autocrat', now pulled by a Mercedes with a manoeuvrable, ready-to-fire 57mm canon. Near the 'agricultural machines' there's an 'arms depot'.

At the last show everything looked so peaceful; and indeed Van Lieshout's self-sufficient community is still peaceful and vital; people work, eat and make love; work hard, make love hard, eat hard. But the weapons are new. What's the point of all these weapons? Surely that's what the police are for in our modern, civilized society.

The logic of the artist

What's the point of all these weapons in the self-sufficiency ideal? What prompted the artist to apply such precision and care to knocking up weapons? Until now everything in the artist's paradise was logical and legal. Of course, the reader mustn't think of it in terms of ordinary, bourgeois logic, because that operates from the lazy havens and crutches of everyday thought, through advertising and sex lines. The artist has his own logic. I'll try to expand on that a bit, but remember it's only an outsider's view of the development of an artist's work. But outsiders are necessary because in the first few decades it's better if an artist's soul is described by someone other than the artist himself. We know the artist through his work.

Van Lieshout's work - his practical objects, his designs and his architecture - has its own individual logic. He's not bothered about beauty, at least it's not a priority. "Beauty, beauty, has burnt its face," said Lucebert back in the fifties. There's nothing to stop us seeing the beauty in his WCs, washbasins, baths and beds, mobile homes and

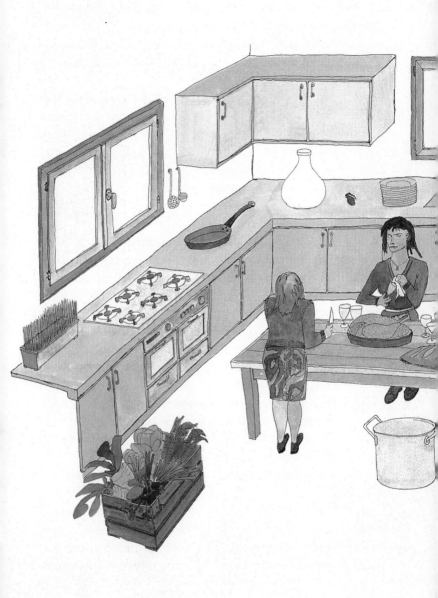

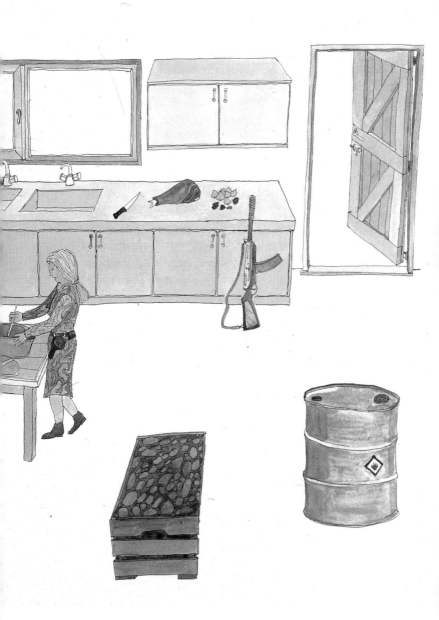

bars; but he's actually after something else. Independence. Self-sufficiency. Survival of the fittest. Lessons in survival.

Van Lieshout obviously doesn't trust contemporary society. He's already invested a great deal of energy in making objects that protect us, such as the skull into which you can withdraw and arm yourself against this hectic society, the relentless, omnipresent deluge of noise, a constant onslaught on life and thought. It's a 'Sensory Deprivation Chamber' in which, just like the 'Orgone Helmets', you can stoke up with new energy. The team at Atelier van Lieshout know they have the support of scientists like Reich and Guattari, but I don't think they need that support; it seems to me to be more a form of reassurance of the correctness of the own logic. In his beautiful skull-rooms, Van Lieshout allows his people to die for a while in order to live, to die in order to gain an understanding of the surrounding world. The surrounding world is meaningless and demands a ridiculous amount of energy. A coffin to keep you alive, it would seem prophetic of a future lifestyle. Van Lieshout doesn't describe his surrounding world (indeed he's got better things to do) but he feels there's something wrong with it, radically wrong, and in response he seeks to discover new forms. Forms that protect him and his kind from the outside world.

The jump to firearms is a logical one, but not innocent. Up to this point the forms of self-sufficiency were legal. But firearms are not. Using firearms is a question of life or death. No humanitarian self-sufficiency system or commune has, until now, needed to resort to weapons. (Leaving aside self-destructive sects, which fall outside the scope of the vital community envisaged by Atelier van Lieshout.) In Walden and Monte Veritá weapons were never a consideration. Even sexually engendered aggression never arose in Walden, at least not visibly as with Van Lieshout.

Aggression is a natural part of life. Aggression (from the Latin word aggredere to approach) is necessary for thought, for trade, for making things, for sex and for art. Aggression is also an element in the exercise of power. And this also applies to Joep van Lieshout: his 'Autocrat' - the ruling power that longs for independence - is a living metaphor of that. In an interview Van Lieshout openly referred to himself as 'headman'. Sexuality and power are closely linked. Sex is an intrusive influence. The psychiatrist Wilhelm Reich has described this relationship and the artist Van Lieshout has picked up on it. There's nothing wrong with power; power is a neutral concept. But it's certainly an art to avoid damaging others in the exercise of power. The artist's at times exuberant phallus representations are not dissimilar to the shape of a weapon. The draughtsman Van Lieshout leaves us in little doubt about that association; one component of the firearm is called 'ejector'. In this respect, too, his 'Workshop for Weapons and Bombs' is a logical progression of his designing. That's one aspect of the artist's logic.

The other aspect is the necessity to protect the love-play, 'the nest', the cosy set-up, the women, the home-made food: in short the idyll of the visibly joyful community with all its comforts. In contrast to the early twentieth-century romantic idyll the artist sees his community threatened by an untrustworthy society. The 'Workshop for Weapons and Bombs' has come under the self-sufficiency category. Self-defence is an ultimate form of self-sufficiency.

The constitutional state

Ready-to-shoot weapons as displayed by Atelier Van Lieshout are illegal. Illegality goes one step further than the simple transgression of boundaries that marks an artist. This places the autocrat in conflict with the existing legal authority and the laws of society. Naturally the artist

has his own logic, as we have already tried to illustrate. But that logic, that feeling, arises out of an examination of the reality of the society around him. That society invites this infringement. There is a reason for personal weapons. Since the Enlightenment it has become clear that feelings are ultimately linked to Reason. We see this happen time and again with an artist who makes practical objects.

The illegality of his weapons takes a different form from that of his 'Workshop for Alcohol and Medicaments'. Making mind-expanding substances falls under the banner of self-sufficiency, as a means of safeguarding you from contaminated drugs for instance. Moreover the drug society is so corrupted by, among other things, violence and the use of weapons, that it's wise to steer clear of it. The illegality of these drugs springs from an obsolete governmental attitude, dating back to the beginning of this century; indeed illegalizing drugs has created its own underworld that has corrupted the upperworld.

But the situation is different with weapons. The illegality of weapons and their use by the ordinary citizen rests on the constitutional state. The constitutional state is a state in which right is above might, in which the law controls power. A rock-solid agreement was made between the government and its citizens: in order to prevent violence the citizen may not use weapons, while the government will protect the citizen against violence and, in so doing, may be armed if necessary. That's what the citizen pays taxes for. That was part of the agreement. The government acquired a monopoly on violence and put it in the hands of the police to protect the good citizen from the bad one (and of the army to provide protection against a foreign enemy). The police are trained in the use of weapons and are subject to laws and regulations. This is a fundamental agreement of any constitutional state, as

long as the police protect the good citizen against the bad one.

The government has held to this agreement for more than a hundred-and-fifty years. Up to the 1970s the police made their presence felt in places where the 'bad citizen', i.e. the violent, robbing or burgling citizen, threatened other citizens. The police were there. And mostly their presence was sufficient. Robbing and violence on the streets, house-breaking, were more the exception than the rule. There were of course potential robbers and violent offenders; every society has a relatively small group who've failed to learn round the kitchen table that one must keep one's hands off other people and their property. In a large city this element usually amounts to no more than two hundred, and the police know about them. The strong arm of the law kept these small groups in check in the cities and the countryside.

The law of the jungle

But since the 1970s the police have increasingly failed in their duty. First the theft of a handbag was met with virtually no reaction or was even ignored, then that same attitude spread to robbery with violence, then to street fights and now to defenceless victims being kicked to death on the ground. The police virtually ignored or reacted far too slowly to incidences of burglary. Thus robbery, violence and burglary steadily increased; there was nothing to keep crime in check and it simply proliferated. The law of the jungle prevails on the streets.

People are turning to the government for help. The public at large want to see the return of the constitutional state, not only on the street but in their own environment (and not just in terms of the generalized phraseology of human rights in foreign countries). Burglary and the law of the jungle in your own home, on your own property, possibly

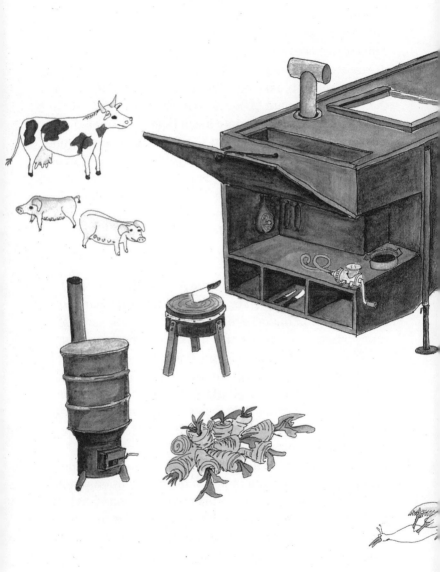

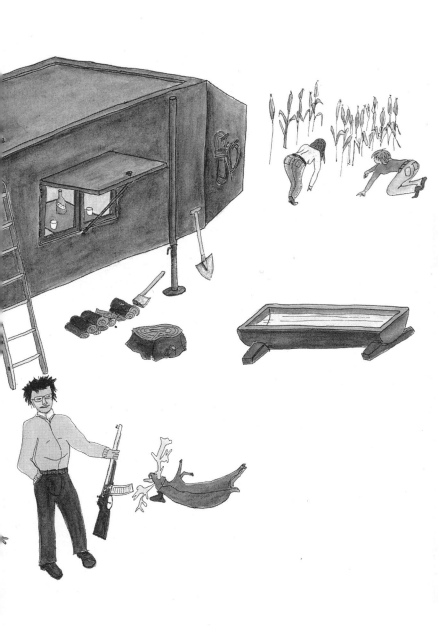

with violence, rings the death-knell for human rights. To paraphrase Churchill's words when he was asked the meaning of a constitutional state, he said: a constitutional state means that if someone taps at your door you can be sure it's the milkman or the newspaper boy. With the war that Churchill helped win long-since past, it's no longer the SS or a German arrest team: nowadays it could be a burglar or even an official.

Why have the police failed since the 1970s? It could be that they're just sitting at their computers; or that they're too busy with reorganization or tracking down drugs; maybe they prefer sitting behind the blackboard, or that some policemen are too frightened to be the strong arm of the law; perhaps they're not motivated to exert their presence in danger areas. Or it could be simply that they've come to resemble your average official. Anything is possible, but the fact remains that, with a few exceptions, the police mostly - often - fail us. (I won't keep on repeating it, but good, active police officers who protect the weak citizen against the law of the jungle do still exist).

The politicians have abnegated their responsibilities. Naturally the safety of the citizen is the prime election slogan, but debates in parliament never get beyond the sacking of a police commissioner, yet another 'reorganization' or 'more officers'.

The general public is in despair. It feels that the government has become increasingly duplicitous and untrustworthy. The laws have become so convoluted, and are so frequently altered in favour of the government's political and economic strategies, that citizens rights have become obscured and the citizen increasingly ends up with the short straw. The plethora of rules and regulations and the general public's lack of understanding of them allows officials to apply the law as they see fit. Power is manipulating the law. Tax increases have brought a corresponding

increase in the number of officials, to the extent that it has created a Fourth Power.

This Fourth Power obscures the constitutional state and is so far-reaching and intangible that public despair has increasingly turned to cynicism, and where at all possible people side-step officialdom. Ministers and members of parliament have long since stopped trying to control this monster that they created at the citizen's expense. The adage that the responsibility lies with the ministers and not the officials is pure fiction, but one that is hung on to like grim death. It's a fiction created by an upperworld that maintains an underworld. 'The Ugly'.

The general public only have to look at the amount of tax they pay to see that it is they who are paying these officials. Therefore in their contact with officialdom they act on the simple human assumption that officials should be working for them or, at least, serving the interests of people and society in general. It's a reasonable assumption, but 992,000 of the million officials show no signs of it.

One citizen who couldn't avoid becoming embroiled with officials relates: "I ask them a question politely and they make me feel I'm making an indecent suggestion, they tell me to wait, that surely I couldn't be so stupid, that I can drop dead, that I'll have to wait a bit longer, that I'm a cheat, that I should wait even longer, that I've got to fill in even more (incomprehensible) forms, that there is nothing they can do about it, that I've got to pay a fine, because that's what the computer says and the computer can't be changed, that the colleague who deals with this has a compulsory day off, that I've got to wait just a bit longer or that I must do all these things at the same time. Above all I get the feeling that officials are actually against the citizen and that there's nobody in that vast machinery, not even someone at the top, who could tell them to be less antagonistic." The citizen continues: "We're a people

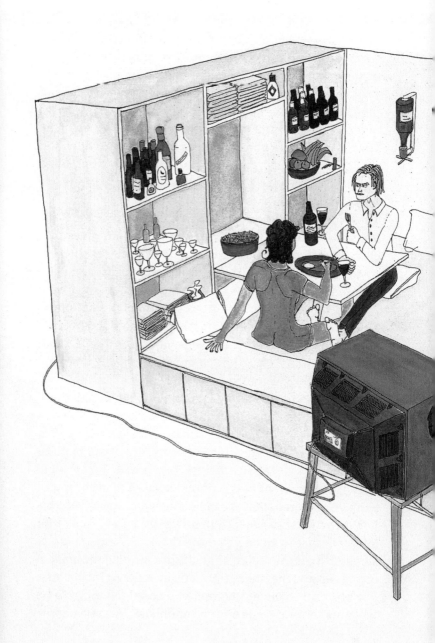

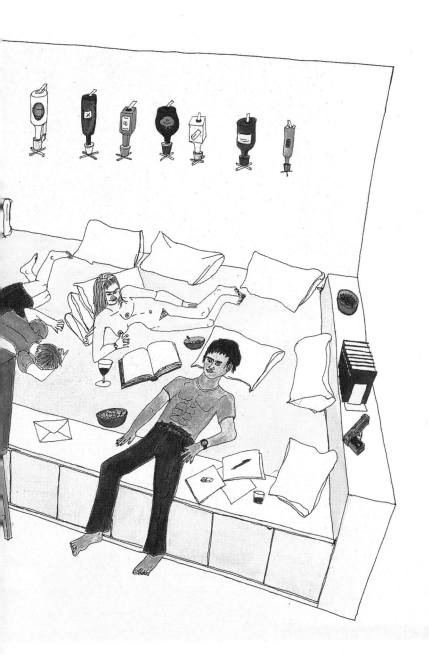

forgotten by the government, marginalized and only useful for paying taxes." That's why Koot and Bie, the satirical duo, said to The Hague: "Don't bother about us and we won't bother about you."

Officials fall outside democracy. Anyone wishing to see that on a large-scale should take a look at the combined European army of officials in Brussels, for ever consolidating its power-base without any democratic control. The official who behaves in a 'client-friendly' way is at best an enlightened despot, but the majority are power-crazed despots.

There's still one ray of hope however for the contact between citizen and official: if you adopt a slavish and dependent attitude, you can eventually extract an answer from the official, or insist on a statement being taken when a policeman is present. But those like Van Lieshout who adopt an independent attitude can expect little good from the state's fourth power.

Against this general backdrop of the relationship between citizen and government, the growing inertia and apathy of the police - the last resort of the weak against the strong, of the good against the bad - only plays into the hands of public cynicism and the 'cowboy mentality', which is so feared by the constitutional state. The police weren't there, the police didn't come, the police no longer report crimes against the body, property or effects. Against this extraordinary backdrop of the relationship between citizen and government the last defence lines between the Good, the Bad and the Ugly have been broken down. The Wild West has returned in the modern middle ages.

Violence and counter-violence

And thus it came about that in Rotterdam an artist saw fit to provide his private working, love-making and eating community with weapons. When the Germans in occu-

pied France, referring to Guernica, asked Picasso: "Did you make that?", Picasso answered: "No, you did." And were the government to ask Joep van Lieshout who made the machine guns and his 'Workshop for Weapons and Bombs' he could give the same reply: "You did." It's not the constitutional state that makes the artist come up with the idea. The artist has a headstart and uses it. He anticipates the situation because he, more than anyone else, experiences, knows and sees that the government can no longer be relied upon. So self-sufficiency, with the strong arm. A prophecy? At any rate it's a forewarning. Unfortunately he may be right. We can't exist without weapons nowadays. They're part and parcel of self-sufficiency in our modern middle ages.

It's normal for artists and scientists to transgress boundaries. But this particular transgression is illegal. The constitutional state itself is at issue. Of course, the unreliable government is the cause. But violence, even defensive violence, opens up a new world, an ugly world. The loving aggression of the phallus, the bed, the love-nest in the room, the women preparing the meal and the slaughtered pig, all need safeguarding, but does it have to be with the old, out-dated(?) armoury of weapons.

Violence and aggression are not the same thing. Violence is aggression gone off the rails. Violence inflicts damage. In itself aggression has got nothing to do with that. You can have violence without aggression. Eichman was an administrative murderer of millions of people. Under the thin veneer of civilization there's a great deal of official violence. Official violence is frequently violence without "raison de coeur", obscure legal proceedings directed against people. Official violence in society has proliferated due to the huge increase in the power of the state in the twentieth century, and the lack of "raison de coeur" of a bloodless bureaucracy more intent on keeping its

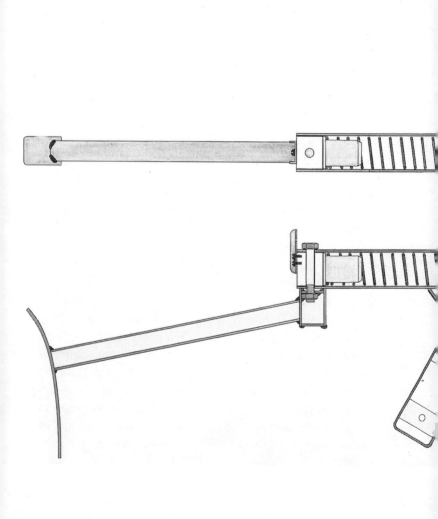

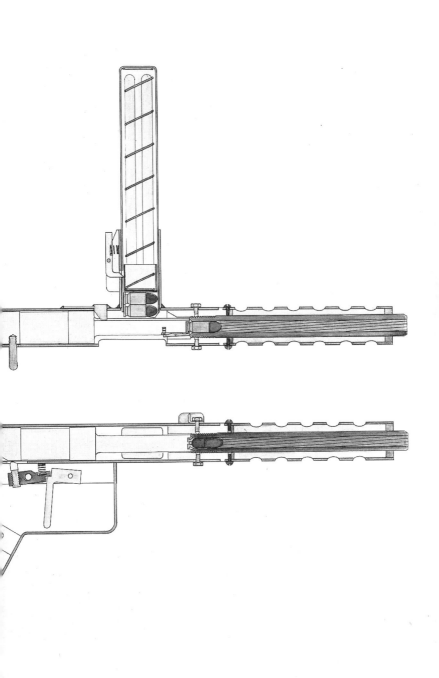

power-base than on humanitarian dealings. That is an 'Ugly' government.

Official violence provokes anarchy. But what about counter-violence? Naturally if you've got to go out in the evenings, or if you have to break the curfew of the law of the jungle, you'll want to minimize the danger by carrying a hand weapon or - as Joep van Lieshout would have it - jewellery that turns your hand into an armed fist.

You've got a weapon at home. Of course you have because, as I've already said, the untrustworthy government has abnegated its responsibilities. If you're armed, however, there's every likelihood that the burglar will be too. But the designer - practical as ever - has come up with an answer: a manoeuvrable canon on a manoeuvrable car, or better still a tank or armoured car in your front garden as well. That should stop them, until your neighbour also decides to step up his counter-violence and the burglars follow suit.

In short: Atelier van Lieshout's show is a warning shot. A presage of spiralling violence. Unless the government takes the artist seriously.

Taking the law into your own hands

Taking the law into your own hands it not allowed. That is the constitutional agreement between government and citizen. Even though the government doesn't stand by its agreement, as things stand, no judge will condone shooting dead a burglar - attacker of women and children - in one's own house; nor, if the burglar and defender are lucky, the use of weapons to wound or put him out of action. The burglar would be more likely to walk free than the defender of body, property and effects. The judge will closely examine and question the suspect - that is the one who was broken into, the one whose wife and children were threatened - as to whether the nature of his defence

was a reasonable means to a reasonable end. In the case of Van Lieshout's guns that would often not be the case. The defence will then argue that the emotion caused by the burglar led to 'excess of self-defence'. But that doesn't usually result in an acquittal, particularly not if Joep himself fired the shot. A man, sound in body and limb, who is suddenly too emotional to realize that the shot from his 'Workshop for Weapons and Bombs' was an emotional excess rather than a logical consequence? The judge would make mincemeat of that. The defender of house, hearth and women is condemned. The judge might just be moved if one of the women from Van Lieshout's kitchen, on seeing a masked villain, had reached for the uzi leaning against the draining board and, unpractised as she is, "by mistake, your honour, hit the burglar at the very spot where the heart happens to be." An excess. Judges sometimes tolerate more emotion from women than from men like Joep. But there have also been cases where women were condemned, emotion or not. In short, taking the law into your own hands is not on, and the defender of body and limb, of property and effects, is sometimes more readily condemned than the dangerous burglar because it's easier for the police to interrogate that suspect - the burglar's victim - than a hardened burglar (who has had a difficult youth and still needs to be examined by a psychiatrist).

What I'm saying is that Van Lieshout with his weapons, however reasonable and however logical they may be, goes radically against the prevailing legal order, the statutory laws and the current administration of justice.

Fifty years on

But Van Lieshout and his kind don't shoot. They make art. Their depiction simply acts as a warning. Watch out, reader. Watch out, government. The artist's logic is a fore-

warning. It may take a long time, but dire necessity can bring about changes to the law. One fine day in the future a smart judge will say in the Supreme Court: "As a result of the systematic absence of the police, who have apparently allied themselves with the army of inert officials, the suspect could only infer that the strong arm would not protect him. Consequently the suspect was entitled to defend himself against intruders (in the manner that the artist Joep van Lieshout heralded fifty years ago). The means that was formerly deemed unjustifiable has become a reasonable means."

The Supreme Court can thoroughly justify his arrest: "The government has not honoured the agreement it made with the citizen; the police were supposed to have used their monopoly on weapons to protect the citizen. They have systematically failed to do this. Therefore to keep the law of the jungle at bay the citizen had no other option but to take the law into his own hands. The arms race between the Good and the Bad is a foreseeable escalation, started by an 'Ugly' government." So said the Supreme Court of the Netherlands in the year 2048 or thereabouts.

BelBin Associates

TEAM ROLE COMBINATIONS REPORT
SPI + OBSERVER DATA

ORGANIZATION: ATELIER VAN LIESHOUT

INTERPLACE originates from the work of Dr. Meredith Belbin, internationally acclaimed father of team roles, whose experience spans over 25 years of personnel research and management consultancy. His team role theory, is widely used throughout the world by many organizations and is taught at many colleges. How the team role concept originated is described in his book Management Teams – Why They Succeed or Fail (1981) which was recently cited by the Financial Times as one of the top 50 business books of all time.

BELBIN SELF-PERCEPTION TEAM ROLE PROFILE
Roles and Perceptions

	CONTRIBUTIONS	ALLOWABLE WEAKNESSES

PLANT (PL)
Creative, imaginative, unorthodox. Solves difficult problems

Ignores incidentals. Too preoccupied to communicate effectively

RESOURCE INVESTIGATOR (RI)
Extrovert, enthusiastic, communicative. Explores opportunities. Develops contacts

Over-optimistic, Loses interest once initial enthusiasm has passed

CO-ORDINATOR (CO)
Mature, confident, a good chairperson. Clarifies goals, promotes decision-making, delegates well

Can be seen as manipulative. Offloads personal work

SHAPER (SH)
Challenging, dynamic, thrives on pressure. The drive and courage to overcome obstacles

Prone to provocation. Offends people's feelings

MONITOR EVALUATOR (ME)
Sober, strategic discerning. Sees all options. Judges accurately

Lacks drive and ability to inspire others

TEAMWORKER (TW)
Co-operative, mild, perceptive and diplomatic. Listens, builds, averts friction

Indecisive in crunch situations

IMPLEMENTER (IMP)
Disciplined, reliable, conservative and efficient. Turns ideas into practical actions

Somewhat inflexible. Slow to respond to new possibilities

COMPLETER FINISHER (CF)
Painstaking, conscientious, anxious. Searches out errors and ommisions. Delivers on time

Inclined to worry unduly. Reluctant to delegate

SPECIALIST (SP)
Single-minded, self-starting, dedicated. Provides knowledge and skills in rare supply

Contributes on only a narrow front. Dwells on technicalities

ORGANIZATION/DEPARTMENT AVERAGE REPORT

This function shows (from Self, Observers or from the complete profile) team-role averages for an Organization or Department – in form of a bar chart. It is followed by a short script pointing out the best and worst scenarios for that particular group based on their group average top and bottom team roles.

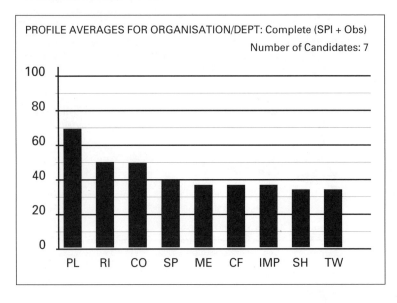

PROFILE AVERAGES FOR ORGANISATION/DEPT: Complete (SPI + Obs)
Number of Candidates: 7

At its best, this intelligent and intellectually able group has the capability of making major advances. However, if this is to come about its talents will need to be carefully nurtured and deployed.

The problem about this team could be the unwillingness of its members to adjust to each other. There may be difficulty in developing team spirit. It may therefore be necessary to find someone who can act as a good lubricant for the group in terms of strengthening morale.

TEAM ROLE COMBINATIONS REPORT

This report allows you to enter between three and fifteen people who may be working together in a team. It will tell you the overall team strengths and weaknesses.

For teams of between 3 and 8 people, this report will show first the overall strength and weakness of the team, secondly, who should be allocated each role and, thirdly, a bar-graph showing on the left the highest individual team-role strengths versus the group average on the right. A low individual score suggests that there may not be a 'good example of that type' in a particular team role. A low group score suggests that the team may be devoid of a particular team role.

An interest in exploring untried possibilities is likely to figure strongly in this team, which should make for a very lively group. But there is some risk that ideas will be advanced in a competitive way and it may be difficult to sort out which ideas should be extracted and acted upon. There will be a key role to be played by someone who is bright, balanced and ready when necessary to take a firm hand.

In allocating tasks and functions within this team, we would suggest:

Roy Aerts
- should be appointed the organizer, responsible for the procedures and practical steps to be taken once the team reaches significant decisions.

Herman de Jongh
- may be the best person to co-ordinate group effort, ensure that everyone has a useful role and that the team works towards a common and agreed goal.

Joep van Lieshout
- is the person best suited to overcoming obstacles and opposition, creating a sense of urgency and ensuring that talk is turned into worthwhile action.

Frank van Ooijen
- should do most of the problem solving or be responsible for generating any new strategies or ideas and proposing solutions to the rest of the team.

Jay Papik
- should play a floating role, using versatile qualities to help with any features of the work that others cannot manage. Should use diplomatic skills to overcome conflict.

Rian van Rijsbergen
- should be responsible for developing outside contacts

and exploring any new opportunities. Needs to be given a chance to conduct negotiations but must report back to the group.

- should ensure that the team's work meets the necessary deadlines and conforms to the highest standards. Responsible for ensuring that there are no inaccuracies or errors.

Yolanda Witlox

- should be made responsible for ensuring that all worthwhile options are considered by the team. Needs a key role in planning. An arbiter in the event of controversy.

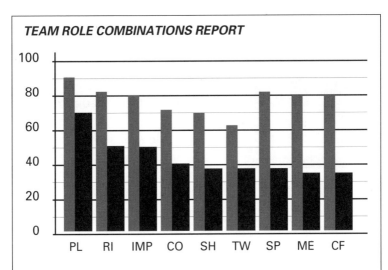

TEAM ROLE COMBINATIONS REPORT

For each pear of bars, the bar on the left represents the individual with the highest overall score in that team role. The bar on the right represents the team's average score.

DESCRIPTION OF CHARACTER PROFILE

This report can be printed either from SPI details alone or on the Overall profile (SPI plus any Observers). Sentences are constructed within Interplace if certain team roles lie above or below specified percentages. Combinations of team role highs and lows form the basis of this report. It may not altogether be complimentary in its output if certain team roles fall below a certain percentage. A rather bland complete profile will get a short report whilst an exaggerated profile will produce a much longer one. If a less direct report is required, then the Counseling report may be more appreciated.

Roy Aerts

• Generally regarded as an individual who is co-operative, disciplined, encouraging of others, loyal, practical, professionally dedicated, and realistic.

• Should be in a job where he can use his acquired knowledge. Keen to follow a professional career path. Above average in terms of self-organization and control.

• Could have problems adapting to a supportive and subordinate role when necessary.

• Should not be involved in work where tolerance of other people's shortcomings is essential.

Herman de Jongh

• Generally regarded as an individual who is adaptable, caring, co-operative, creative, and encouraging of others.

• Has innovative tendencies and needs to work in a mentally challenging environment. Could be good at solving complex problems or at introducing new ideas. Likely to be drawn to work that exercises his mind. Requires some

form of intellectual stimulation. Has an interest in drawing out contributions from others and making the best use of a team. Someone who thinks before acting. A discriminating mind valuable at the planning stages of an operation. Inclined to lack a sense of urgency.

• Uncomfortable when having to deal with pressure.

• Should not be involved in work where dealing with sensitive people is important.

Joep van Lieshout

• Generally regarded as an individual who is competitive, creative, enterprising, hard driving, knowledgeable, opportunistic, persistent, and professionally dedicated.

• Has innovative tendencies, needs to work in a mentally challenging environment. Could be good at solving complex problems or at introducing new ideas. Needs to be in a job where he can use his outgoing nature. Likes to use personal initiative. Dynamic and entrepreneurial. A developer of new ventures. Likes to be in a job where he has some authority. Has a capacity for self motivation. Prefers to lead rather than to support. Keen to explore and develop new ideas. Needs to work in an environment, which offers scope for personal expression.

• Could have problems adapting to a supportive and subordinate role when necessary.

• Should not be involved in work where tolerance of other people's shortcomings is essential.

Frank van Ooijen

• Generally regarded as an individual who is creative and technically skilful.

• Has innovative tendencies, needs to work in a mentally challenging environment. Someone who may have difficulty in establishing his best contributory role.

• Could have problems adapting to a supportive and subordinate role when necessary. Needs to develop more in helping people to achieve their work goals.

• Should not be involved in work where careful planning is required.

Jay Papik

• Generally regarded as an individual who is adaptable, co-operative, and loyal.

• Has innovative tendencies, needs to work in a mentally challenging environment. Has a pleasant and accommodating attitude. Keen to get on well with colleagues.

• Uncomfortable when having to deal with pressure.

• Should not be in work where there is a need for consistency.

Rian van Rijsbergen

• Generally regarded as an individual who is caring, conscious of priorities, consultative, and professionally dedicated.

• Needs to be in a job where she can use her outgoing nature. Likes to use personal initiative.

• Has an interest in drawing out contributions from others and making the best use of a team.

• Should not be involved in work where dealing with sensitive people is important.

Yolanda Witlox

• Generally regarded as an individual who is caring, co-operative, and loyal.

• Has innovative tendencies, needs to work in a mentally challenging environment. Someone who may have difficulty in establishing her best contributory role.

• Poor at dealing with practical issues.

• Should not be involved in work where dealing with sensitive people is important.

MOST HIGHLY RATED RESPONSES

This list shows words from Observers Assessments and their scores in descending order of popularity.

WORD	SCORE	WORD	SCORE
creative	34	original	13
co-operative	34	innovative	13
loyal	33	tough	12
caring	30	opportunistic	12
professionally dedicated	30	competitive	12
enterprising	27	shrewd	11
adaptable	24	inquisitive	11
knowledgeable	24	empire building	11
technically skilful	23	diplomatic	10
practical	23	impartial	9
encouraging of others	22	fussy	9
self-reliant	22	persuasive	9
broad in outlook	21	impatient	9
conscious of priorities	21	erratic	8
consultative	20	forgetful	7
realistic	20	provocative	7
clever	20	territorial	7
outspoken	19	laid back	7
good at follow through	19	single-minded	6
persistent	19	reluctant to delegate	6
critical	19	skeptical	6
imaginative	18	up-in-the-clouds	6
disciplined	18	perfectionist	5
outgoing	18	manipulative	5
calm & confident	18	aggressive	5
challenging	17	easily bored	4
efficient	17	frightened of failure	4
unorthodox	16	fearful of conflict	4
analytical	16	slow-moving	4
accurate	16	indecisive	4
impulsive	15	inflexible	3
hard driving	14	unadventurous	3
observant	14	insular	2
logical	14	over-sensitive	2
well organized	14	resistant to change	2
conscientious	14	not interested in others	2

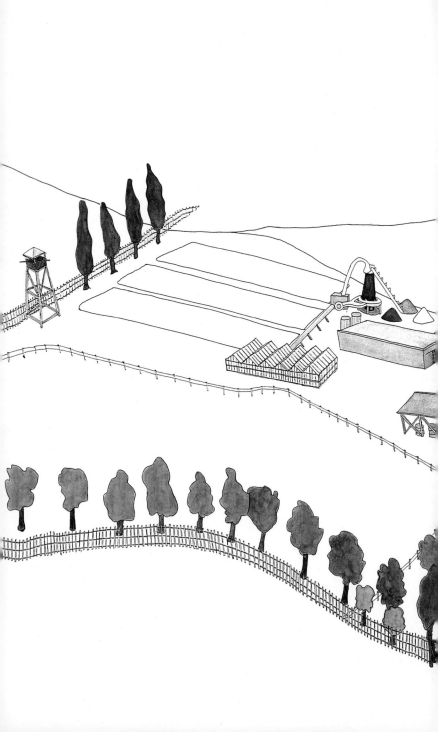

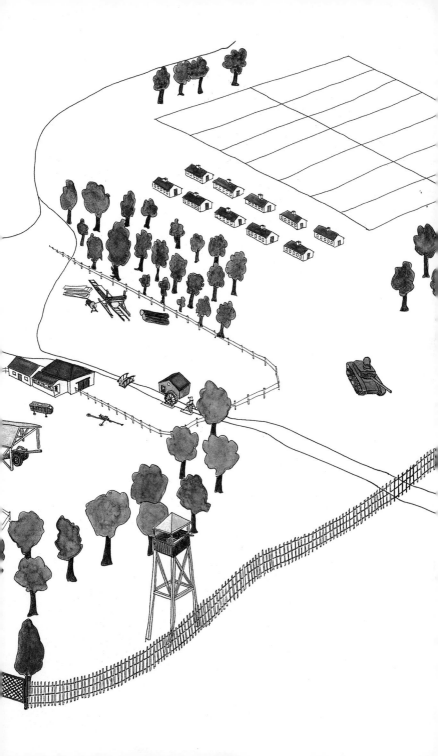

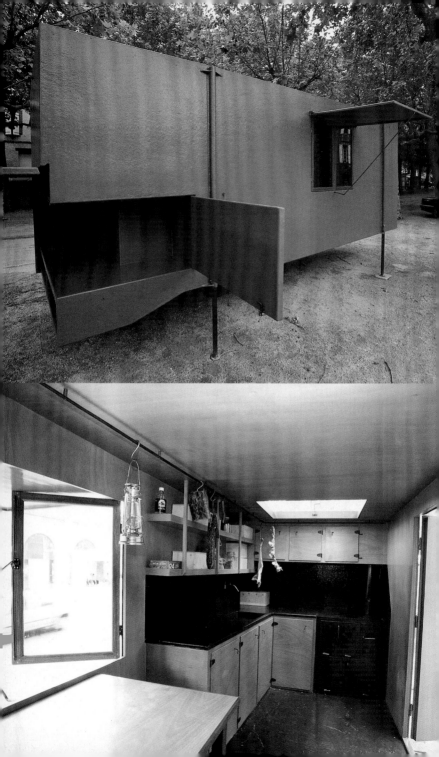

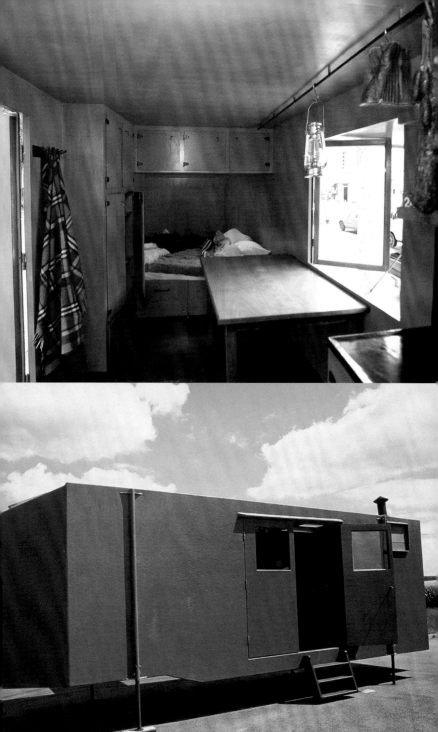

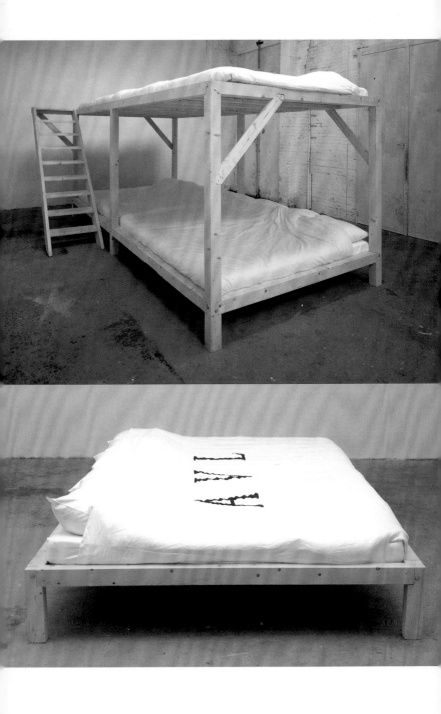

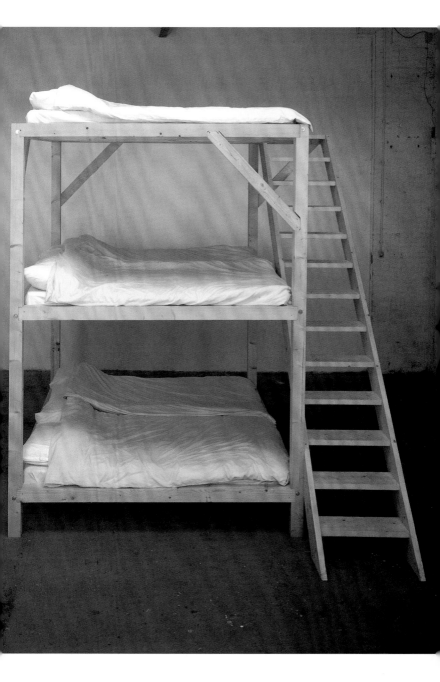

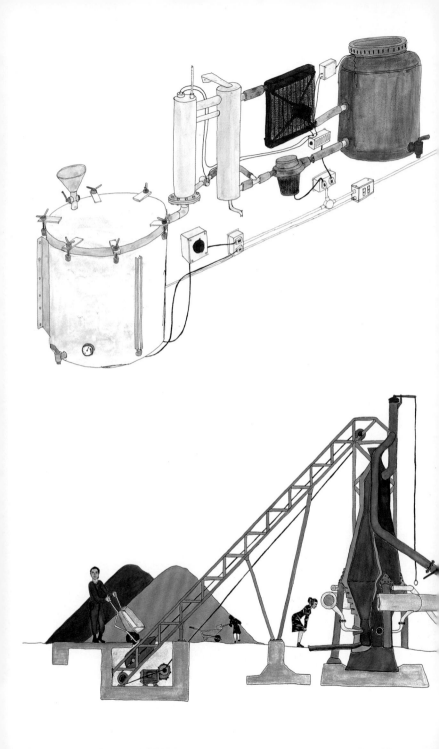

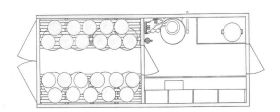

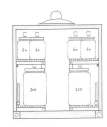

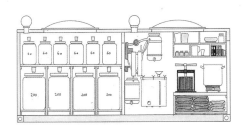

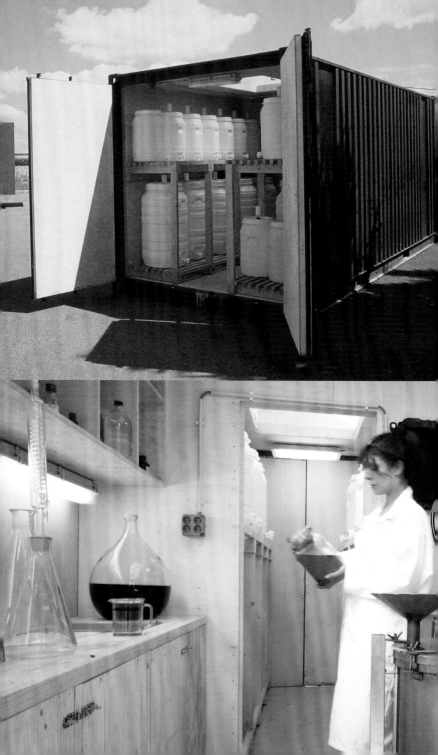

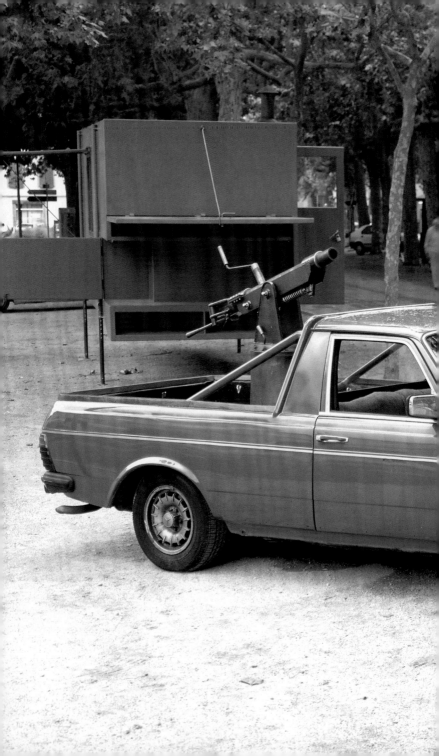

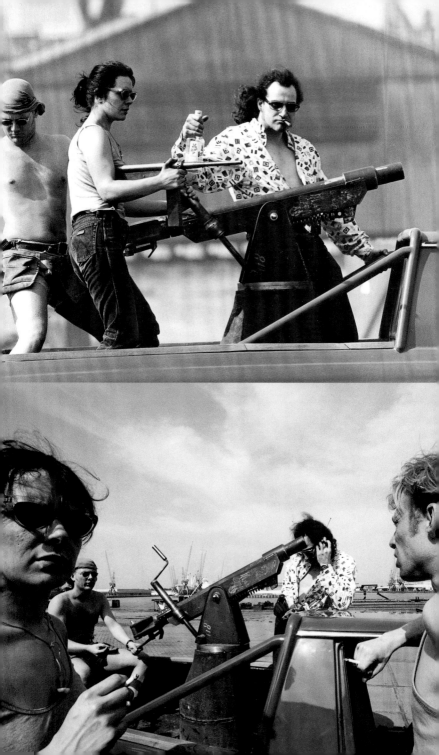

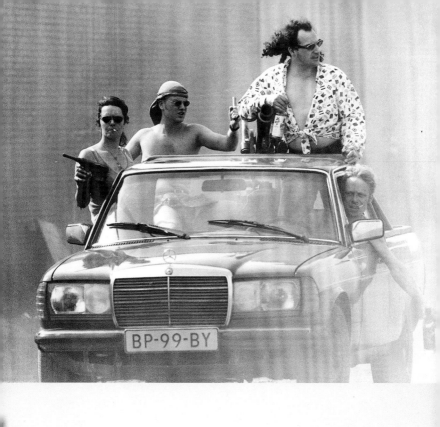
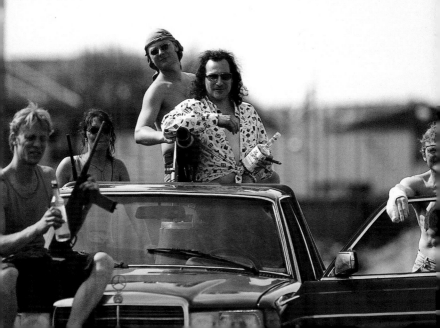

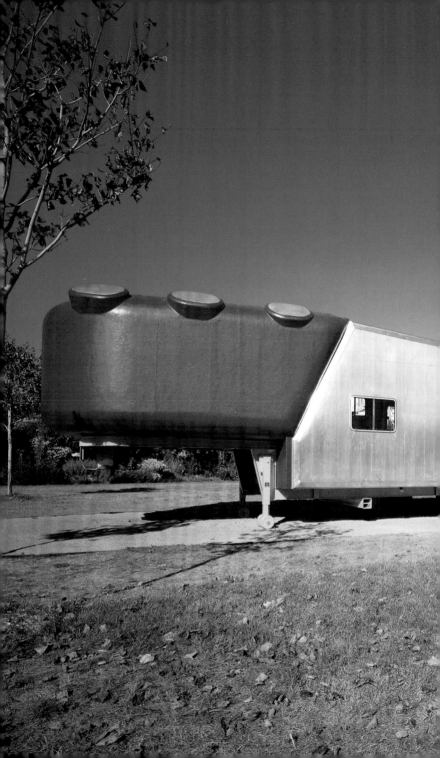

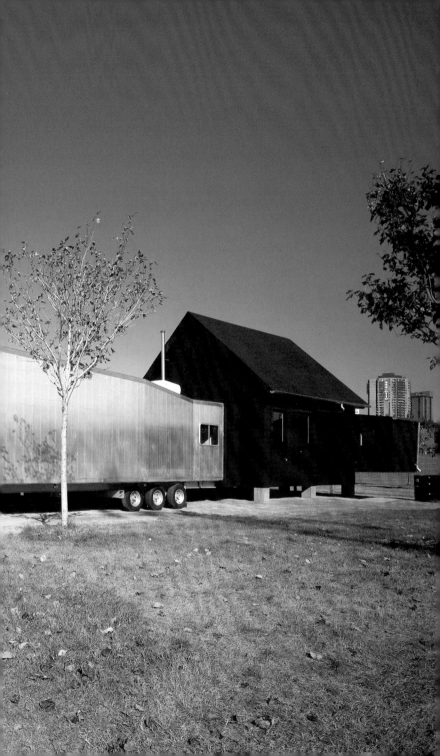

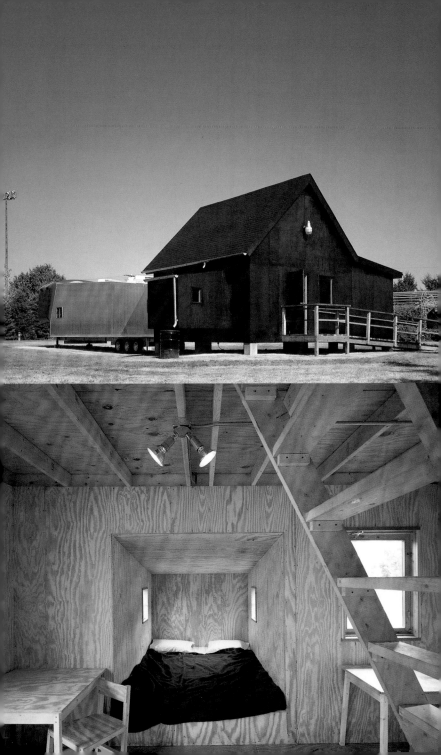

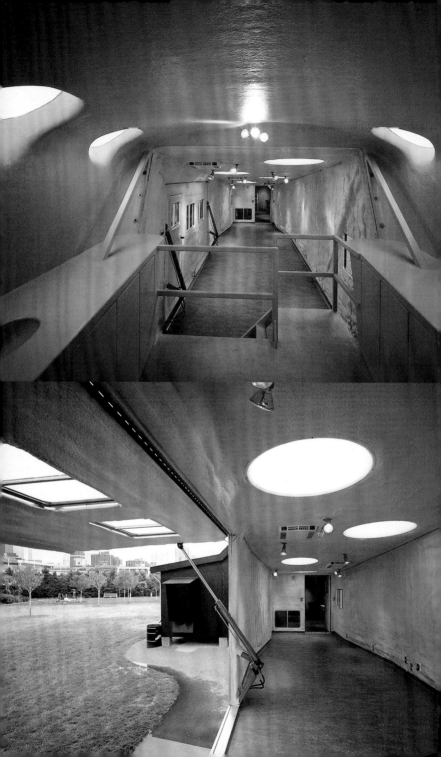

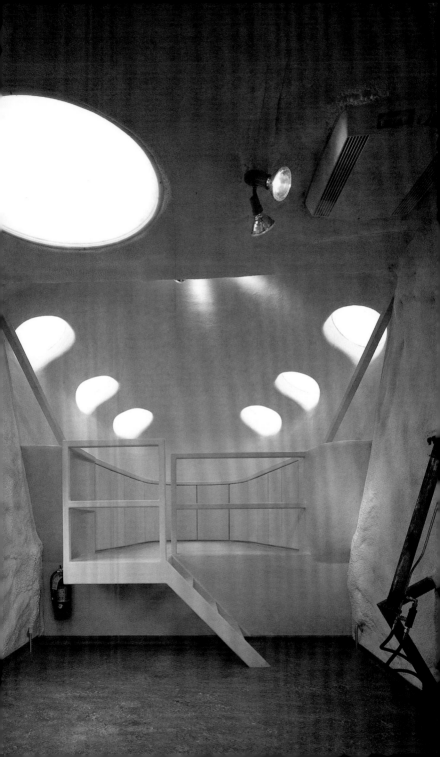

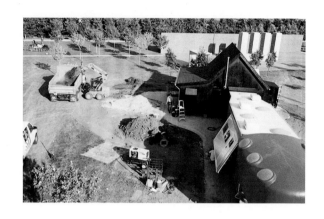

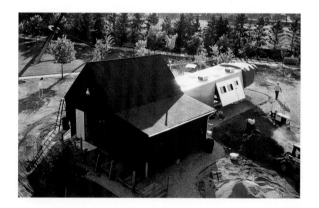

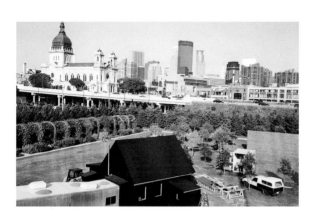

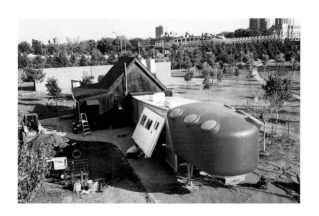

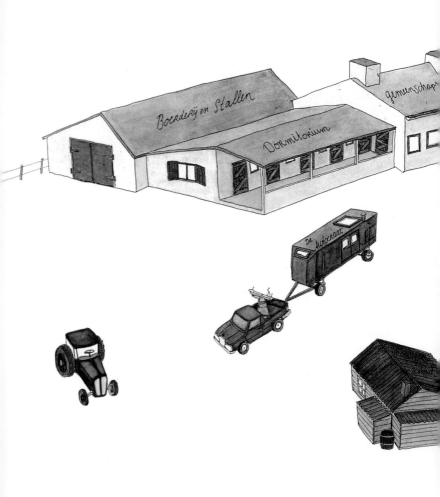

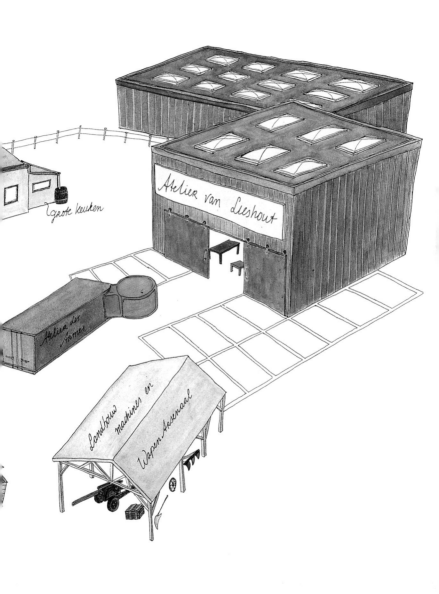

Grote keuken

Atelier van Lieshout

Atelier des James

Landbouw machines en Wapen-Arsenaal

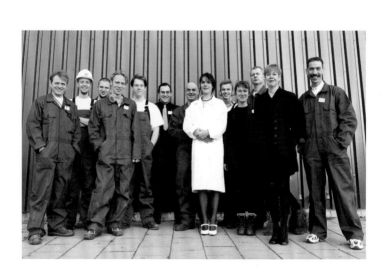

CAPTIONS

Prick Tree, 1997
Little Man, 1997
Little Prick, 1993
Little Prick, 1993
The Pitiful One, 1996

Untitled, 1998 (kitchen)
Untitled, 1998 (Autocrat)
Untitled, 1998 (commune bed)
Untitled, 1998 (gun)

Untitled, 1998 (masterplan)
66x89cm, watercolour on paper

Autocrat, 1997
310x700x225cm, mixed media, polyester, exterior, interior

Modular Multi Women Bed, 1998
193x275x492cm, wood, bedclothes

Modular Multi Women Bed-AVL, 1998
40x372x218cm, wood, bedclothes

Modular Multi Women Bed, 1998
293x288x258cm, wood, bedclothes

Untitled, 1998 (still)
50x70cm, watercolour on paper

Untitled, 1998 (Workshop for Alcohol and Medicaments)
50x70cm, watercolour on paper

Untitled, 1998 (blast furnace)
69x96cm, watercolour on paper

Workshop for Alcohol and Medicaments, 1998
220x600x220cm, mixed media, polyester, herbs, raw
materials , exterior, interior

Workshop for Weapons and Bombs
with Sleep/study Ball, 1998
4 sections , 220x600x220cm, 150x235x235cm,
150x300x235cm, 170x170x180cm, mixed media, poly-
ester, equipment, chemicals, polyurethane foam
exterior, interior

Mercedes with 57mm Canon, 1998
2 sections , 140x490x200cm, 125x40x140cm, customized
Mercedes pick-up, polyester, steel

The Good, The Bad & The Ugly, 1998
Walker Art Center, Minneapolis, Minnesota, Commission

The Good, The Bad & The Ugly, 1998
630x750x930cm (wooden house), mixed media
exterior, interior

The Good, The Bad & The Ugly, 1998
400x345x1500cm (mobile unit), mixed media, polyester,
interior

Untitled, 1998 (Atelier van Lieshout)
66x89cm, watercolour on paper

Survival knife, 1995
Pistolet Poignée Americaine, 1995
Pistolet Poignée Americaine, 1995
Machine gun, 1983
57mm Canon, 1998

Bart Lootsma

THE GOOD, THE BAD + THE UGLY OR: SYMPATHY FOR THE DEVIL

The photo shows Joep van Lieshout, leaning on a self-made 57mm canon on the loading platform of his customized Mercedes pick-up truck. A man of the world, he wears a shirt with flags, held together round his stomach by a knot. His hair is long and he is wearing sunglasses. In one hand he is clutching a bottle of bourbon and a cigar. He is surrounded by some of his staff - three men and a woman - who also look like freebooters with their bare torsos, headscarves, sunglasses and dishevelled hair. Some of them are holding self-made machine-guns or bottles of liquor, or both. One of them - standing slightly apart from the rest - is leaning on the open door wearing protective goggles and has a bandage round his hand: people who play with fire get burnt. It is not clear whether they have just come back from some successful mission or whether they are just about to set off, or perhaps the whole thing is just a joke. Whatever, they seem to be enjoying themselves, judging from the huge grins on their faces. It looks like a still from a film or a cheap television series. Someone probably facetiously called them 'The Good, The Bad and The Ugly', referring to Sergio Leone's famous Spaghetti Western. Maybe that is what they are all laughing about on the photo. "We'll keep that in", somebody retorted, and 'The Good, The Bad and The Ugly' became the title of a series of works and shows by Atelier van Lieshout. These turned out to be the preparations for what will end up as a separate autarkic community outside the city.

Cowboys and Samurai

That is probably more or less how it happened, but of course that title was no accident. Sergio Leone's film is about three outlaws at the time of the American Civil War. All three are out to get rich, and so a chest full of gold coins buried somewhere figures prominently in the film.

By coincidence the three protagonists end up searching for it. And although they are all purely intent on personal profit, during the course of the film they are constantly thrown together in bizarre relationships of interdependence and collaboration, the most famous being the perverse relationship between The Good (Clint Eastwood) and The Ugly (Aldo Giuffre). There is a price on The Ugly's head, which Clint Eastwood repeatedly collects because he hands him over as a bounty hunter. When The Ugly is finally strung up, The Good - with that mythical precision which is the hallmark of the Western hero - shoots through the rope and they escape together to the next town. Who is on top and who is under is constantly changing as the film proceeds. Or as The Good says at one point: "There are two kinds of people in this world: those with guns and those who dig." Although ruthless and often cruel, all three protagonists have a strong sense of morality. They each have their own rules they live by, even The Bad (played by the Dutchman Lee van Cleef). True he kills on commission, but if the character he is hired to murder pays him to kill his client, he will honour the agreement to the letter. These cowboys are modelled on the Samurai that appear in some of Akira Kurosawa's films, nomadic horsemen whose code of conduct turns them into lonely and tragic figures. The villains' individual morality - however questionable it may be - is presented in the film as the madness of a country at war, which forms a permanent backdrop and sweeps everyone along with it. The chest of gold - war gold - that lies in store will permanently free the one who finds it from this madness.

Spaghetti Westerns

The film 'The Good, The Bad and The Ugly' was made in 1966. Sergio Leone, who launched his career in 1948 with

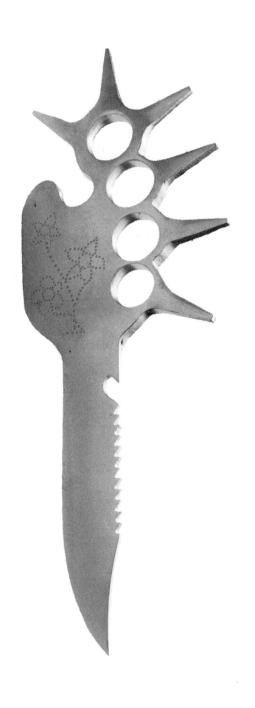

a small part in Vittorio de Sica's socio-realistic drama 'Ladri di Biciclette' and went on to work as assistant to other Italian film directors, set the tone for the Spaghetti Western with 'For a Fistful of Dollars' of 1964. Spaghetti Westerns were originally low-budget Westerns made and financed in Europe. It is hardly surprising, therefore, that they frequently provide a cynical comment on American society, albeit couched in a cryptic 'film noir' style. They were taken up by the sixties American counterculture, by the radical hippies, Vietnam veterans and Hell's Angles, who strongly identified with them. It takes little effort of the imagination to see Dennis Hopper's film 'Easy Rider' of 1969 as a contemporary variant of the Spaghetti Western, in which the horses have been replaced by customized motorcycles, beautifully styled choppers that serve to further reinforce the striving for individuality and personal freedom that the main protagonists show in their behaviour. Originally intended for those long, straight American highways, choppers were crudely adapted, Harley Davidson army motorbikes, used by veterans from the Korean and later Vietnam war who no longer wished, or were able, to adapt to everyday life, and who led a nomadic existence as Hell's Angels.

Counterculture

At the end of the fifties a bond and a friendship emerged between some groups of Hell's Angels and early beatniks, like Bob Dylan, the poets Ferlinghetti and Ginsberg and the Italian designer Ettore Sottsass. Sottsass relates how they drove around at night visiting other like-minded friends who had rejected the bourgeois consumer society and everything to do with it. They lived in empty rooms with only a mattress on the floor and took their few sticks of furniture from the street or the rubbish dump. If they got a new fridge they would immediately disfigure it by

scratching it with a pair of scissors, thereby, as Sottsass put it, turning such objects into a sort of sepulchral monument in the empty space.[1] These inspired him to design a furniture series which, as the photos taken in empty rooms show, look like "menhirs in the midst of the remnants of what was once a traditional household life".[2] Although in retrospect Sottsass's furniture comes across much more stylized and therefore more bourgeois than Van Lieshout's, there is a striking similarity between the atmosphere of the early sixties described by Sottsass and the lifestyle that Van Lieshout has in mind. An important similarity is their predilection for (over)large beds as the focal point of the domestic space.

Ambivalences

Leaving Sergio Leone's film aside, 'good, bad and ugly' was always a characteristic of the work produced by Atelier van Lieshout. From the outset Van Lieshout's work engaged in a discussion with modernity, one which did not regard it as a utopian project, but as something the results of which are there for all to see. This seems to alter or even pervert the meaning of modernity. In previous publications on Atelier van Lieshout's work I have described the Atelier's approach as one of 'active indifference', in the same sense as Georges Bataille spoke of Edouard Manet's work - an approach that aimed to "shatter expectations". Bataille maintained that it was precisely this that made it possible for Manet to capture the essential characteristics of his time.[3] Much of Van Lieshout's work - from the stacks of beer crates, pavement stones and dustbin bags, to the serially produced furniture and sanitary units, as well as the professionalized business organization of the Atelier - can be seen as a series of attempts to understand the unwritten rules of modern art and design, and to play around with them.

This brings to the surface the myriad ambiguities and ambivalences of modernity.

The legacy of the sixties

In a similar way the legacy of the sixties is something that is now surfacing everywhere. The message of the Spaghetti Western, the hippies and the Hell's Angels has been corrupted in commercial television series like 'The A-Team', where a group of veterans who deserted from Vietnam - all of them distinctive or even bizarre individual characters on the run from court martial - drive round in a customized truck of the type used by shady builders and odd-jobbers. In principle (if we are to take the series seriously) the A-Team, who are driven by a strong personal feeling for justice, come to the rescue of people who have been left in the lurch, or even directly threatened by the corrupt government. On the spot, in no time at all, they spontaneously conjure up an impressive arsenal of weapons with which, at the climax of the programme, as many people as possible are killed and cars blown up, leaving their grateful proteges behind. Colonel Hannibal Hays in the series chews on a cigar just like Clint Eastwood in 'The Good, The Bad and The Ugly'. In a different way, the A-Team has also learnt a lesson from 'Easy Rider', namely that it is better to be armed oneself and to shoot than be shot dead by those appalling American farmers. This successful series is still being repeated endlessly today by commercial television stations. In 1984 Joep van Lieshout wrote a scenario for a variant on this genre of film and television series entitled 'S-TEAM SATAN' in which he, of course, plays the main role. The script describes a souped-up truck with Van Lieshout, in his all-American outfit on the loading platform, machine-gun in hand visibly enjoying himself shooting at small fleeing figures; once they are dead he jauntily sets off "in search of another small car or figure".

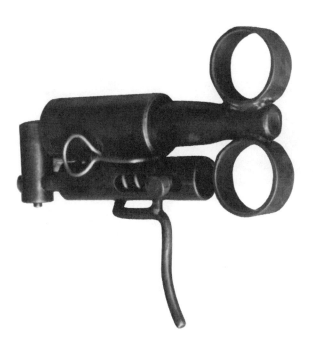

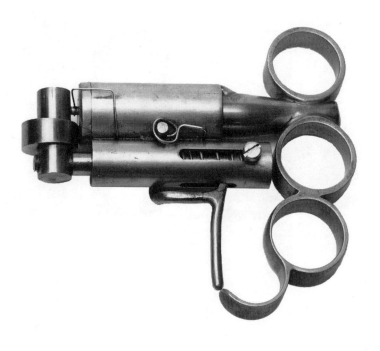

But it is not only in the media that the sixties message is perverted. The hippies of that time form today's establishment. As the Rolling Stones's bodyguards in 1969, the Hell's Angels were regular murderers, who at the notorious concert in Altamont simply went around knifing overobtrusive fans, as George Lucas showed in his film 'Gimme Shelter'. In the meantime the Hell's Angels have developed into an ordinary criminal organization with large-scale dealings in drugs, whose various different clans fight it out with serious weapons. Moreover figures like the UNA-Bomber, a country loner whose strong sense of morality drove him to unleash his lethal explosives on the American university population, have also undermined the hippy movement's innocent image.

Periphery and autocracy

Atelier van Lieshout operates on the fringe of society and sponges off its left-overs, as did the beatniks and hippies in the sixties. Literally, too, the Atelier is located on the periphery, in an old factory building in one of the most run-down industrial zones of Rotterdam harbour. Opposite there is an old gasometer which has been converted into a transit shed. The sheds around house countless indeterminate small enterprises, artists, builders merchants and second-hand car dealers. The Atelier looks out onto an authorized zone for street prostitution set-up by the council. It is hardly surprising then that this area breeds ideas for a form of society that could be entirely autarkic, preferably even further outside the city.

This longing for autarchy first explicitly manifested itself in the mobile home, the 'Autocrat', which Atelier van Lieshout built in 1997. Before that the Atelier had built a number of caravans and campers, but those were more like luxury products. Although the 'Autocrat' is exceptionally spartan, it is equipped with a kitchen and slaughtering

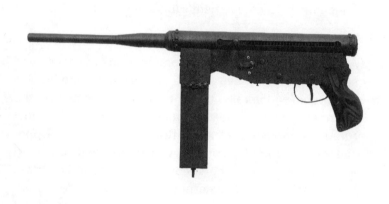

facilities, which means that in principle it is possible to live self-sufficiently far from civilization. This same period saw Atelier van Lieshout slaughtering their own animals for which they made the necessary equipment. Somewhat later they started distilling their own alcohol to make spirits and medicines, as well as producing weapons. As Van Lieshout puts it: "They're simply something you've got to have." Over the last year Atelier Van Lieshout has been working on plans for building a new commune or camp-style settlement. Drawings and models have been made, various locations explored, the Atelier is being vetted to see whether it is practicable for the staff to live together, and the economic viability is being rigorously examined. It is all these activities that are currently being showcased in various exhibitions and in different constellations under the title 'The Good, The Bad and The Ugly'.

The devil's advocate

Alongside admiration, Atelier van Lieshout is also attracting increasing opposition. This opposition is sometimes of a purely formal nature, such as when weapons are impounded, at others it is emotional, as when the show 'The Good, The Bad and The Ugly' was closed down in Rabastens in France in the summer of 1998. Strictly speaking Atelier van Lieshout's work transgressed boundaries from the very outset. We see this already in the stacks, the furniture and the sanitary units; these transgressed the boundaries between design and visual art. At first sight this would appear to be an academic debate, yet some members of the editorial board of the Dutch design magazine 'Items', which featured the work, became extremely worked up about the matter.[4] It even occasioned a full-scale row within the board which prompted several editors to resign.

With his architectonic proposals Van Lieshout side-steps

and transgresses architectural mores and regulations. Up to a point this passes unnoticed because his constructions are classed as art, viewed as temporary, or because his mobile homes have wheels and thus, according to Dutch law, do not come under the category of buildings or living contingent. But with the refurbishment of the facade of the Galerie Fons Welters in Amsterdam, the Atelier fell foul of the Building Inspectorate and the Design Review Committee because planning permission had not be applied for. Regulations apart, Van Lieshout also transgresses the mores of architecture because he is purely out to please his individual clients with his constructions, whereas what is singular about his architecture is that it seeks to find a balance between the desires of the client and the needs of society. With his slaughtering, distilling, polygamy and the production of weapons, however, Van Lieshout is increasingly falling foul of the law. Sometimes he pleads his position as an artist, sometimes he conforms by applying for the necessary permit, sometimes works are removed from shows or impounded. The transgressions are becoming less and less academic, although Van Lieshout as an artist still seems to occupy a privileged position. Art, film and perhaps also literature appear to be the last remaining free places for these kind of experiments, albeit that this freedom appears increasingly less guaranteed.

With this new series of works the role of Atelier van Lieshout is starting to look more and more like that of the devil's advocate. We need him in the same way as the FBI agent Clarice Starling, played by Jody Foster in the film 'The Silence of the Lambs', needed the advice of the disturbed psychiatrist and serial murderer Hannibal Lecter in order to be able to empathize with another perverse serial murderer and track him down. This last hippie lived entirely unnoticed in a respectable house in a small

American town. He lured his victims under the pretext of needing their help to move house, using a similar pick-up truck as that used by the A-Team and the S-Team. In a secret cellar under his house he carefully skins his victims, using their skin to take on another identity. In the process Clarice Starling comes to understand herself, and realizes that she did not become an agent to serve the law or because it is what her dead father did, but to save innocent people. Hannibal Lecter scoffs at her. That is the most important theme of 'The Silence of the Lambs', and it is no accident that the film takes its title from the crucial moment in that process of self-realization.

Individualization

Individualization has become one of the most important phenomena of Western society over the last few decades. In the West individualization is often equated with Americanization and capitalism because in American culture individual freedom is glorified to the hilt. (European) sociologists like Ulrich Beck and Anthony Giddens see individualization as a logical extension of globalization, the hugely increased affluence, mobility, communications and independence. They see individualization as a necessary transitional phase towards new forms of society in the second phase of modernity. Whereas the classic industrial society embraced a direct correlation between class, family, sexual role-patterns, division of labour between men and women, marriage and architectonic and urban planning typologies, today increasing numbers of people have the opportunity to exchange the standard biography for a biography of their choice: a 'do it yourself' biography as Ronald Hitzler calls it, or as Giddens puts it a 'reflexive' biography. According to Ulrich Beck, individualization implies "first, the disembedding and, second, the reembedding of industrial society ways of life by new

113

ones. In which the individuals must produce, stage and cobble their biographies themselves." Beck sees the reflexive element in the cobbling together of a personal biography specifically in terms of the confrontation with another. And that is something that will inevitably play an increasingly important role at the point where society condenses and the assertiveness and fighting instinct of the individual rises up. This sets up a "chaotic world of conflicts, power games, instruments and arenas which belong to two different epochs, that of 'unambiguous' and that of 'ambivalent' modernity. On the one hand, a political vacuity of the institutions is evolving and, on the other hand, a non-institutional renaissance of the political." According to Beck the subject is in the end thrown back on the institutions of society.[5] The flight or voluntary banishment to the periphery or the country is of course also a solution - although possibly a temporary one - and that appears to be the option that Atelier Van Lieshout has chosen for the moment, since they are investigating the possibility of setting up a totally autarkic commune with its own rules for living.

Hold on and let go

Atelier van Lieshout sees the striving for autonomy as a universal striving, as does sociologist Anthony Giddens. It is already present in the growing child, who gains increasing control over his body and other faculties, such as speech. All that is an expansion of autonomy. It is also a right, says Giddens: "Each individual has the right - varying in content in manifold ways in different contexts - to maintain a distance from others by preserving bodily privacy and integrity of self." But expanding autonomy must be brought into relation with others with whom the individual engages socially. Giddens connects this conflict between autonomy and engagement also with the

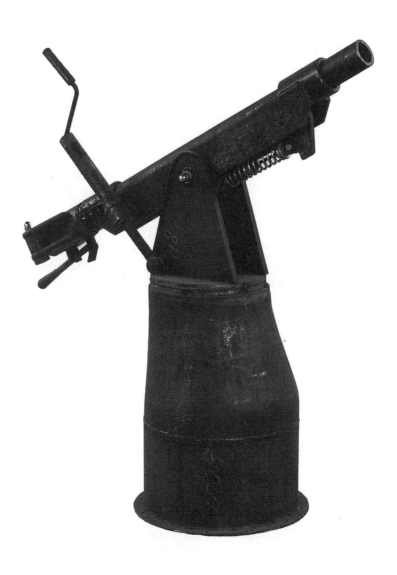

pleasure zones of the body: "Holding on and letting go are the behavioural correlates of the main polarity on which this stage (in the development of the child, B.L.) is centred, autonomy versus doubt or shame. As with the prior phase, with which it can stand in a relation of generalized tension, the polarity can be resolved in a relatively benign or more disruptive way. To hold on as a greedy mode of retention can represent a cruel self-absorbtion or can be a pattern of care expressing autonomy. Letting go can similarly be a hostile expression of aggressive impulses or a more relaxed attitude to 'letting things pass'." [6] In previous articles I have already pointed out that both attitudes are represented side by side in Van Lieshout's work. On the one hand there are the interiors, the skulls and the 'Orgone Helmets', which represent the longing for withdrawal. And on the other there are the phalluses, weapons and (racing)cars, about which Van Lieshout once said that they are "the things that he can't do without". Referring to Deleuze and Guattari I made a comparison with their concept of the pulsating wish-machine of the schizophrenic. In Deleuze and Guattari's view, a schizophrenic is not so much someone who has problems with his parents but with the endlessly changing couplings of capitalist society.[7] This relates back to the problem of individualization, as formulated by Giddens and Beck, as the necessity to cobble together for oneself a reflexive biography, one that takes other(s) into consideration. In modern Western society that other is not just a physical presence, but also the 'absent other' (Giddens), as represented by 'abstract systems' of laws and regulations, standardization and areas of scientifically acquired expertise.[8] Thus Giddens would formulate the problematic discourse with the other not so much as something generated by capitalist society, but as a conflict with democracy. "Democracy (...) implies not just the right to free and equal self-development, but also

the constitutional limitation of (distributive) power. The 'liberty of the strong' must be restrained, but this is not a denial of all authority - or it only becomes so in the case of anarchism."[9]

Free zones

For the time being Atelier van Lieshout appears to be oblivious of all that. The do-it-yourself ethos has been elevated to a guiding rule for life. What they intend is not simply an autarkic enclave within society, but an enclave dominated by an autocracy, with Joep van Lieshout as the undisputed leader. They demand nothing from society, seeking only to live by their own rules and to cobble together their own biographies into one, large, living artwork. They are taking the preparations very seriously. The entire Atelier has been vetted by management consultants and every member of staff has been psychologically tested, evaluated, characterized and assigned a possible role in the undertaking, to ascertain whether they will be able to stick it out together. The results of the report read like character sketches for the casting director of a film.

This quest for a free zone is not an isolated event in the Netherlands. This country is currently undergoing a process of deregulation, while at the same time becoming ever more densely populated and built-up. It fits in with a series of large and small-scale proposals, such as the proposal for a 'de-zoning plan' that NL.Architects recently presented in Gouda; Carel Weeber's plea for 'Wild Living'; Adriaan Geuze and West 8's proposals for national free zones for Innovation and Acceleration (with its own personal Ministry) and Rem Koolhaas, OMA and NYFER's MAA$VLAKTE (note the dollar sign instead of an S!!) project for Rotterdam harbour.[10] These are all proposals for zones where individual freedom, private initiative and market forces are expanded by by-passing local regula-

tions. These plans reveal remarkable and perverse parallels with the areas of polder-land that were returned to nature in the seventies and eighties under pressure from hippy ecologists and have since been designated nature reserves, but equally with the tax-free zones at international airports.

The difference is that Atelier van Lieshout seems prepared, if necessary, to undertake this itself (on a relatively small scale) and thus, suitably armed, to defend their values: like a 'Wild Bunch', to quote another famous Spaghetti Western. The question is how will society react to this? Will they really take it seriously? Will they ask themselves what the difference is between this and every other venture with its own security service? Will they turn a blind eye to it as an artistic experiment? Or will they simply tolerate it as they have motorbike clubs, squatters, prostitutes, drug users and gypsy camps? Unlike many other countries, there are numerous precedents in the Netherlands for this type of 'policy of tolerance'. The mayor of Rabastens, however, already felt so seriously threatened during the presentation of the preparations that he closed the exhibition 'The Good, The Bad and The Ugly' down after only a moment's hesitation. This provoked a storm of protest. The real test will come if Atelier van Lieshout really does establish itself somewhere communally.

Notes:

1) Ettore Sottsass, notes for a lecture, as quoted by Penny Sparke in : Penny Sparke, *Ettore Sottsass Jr.*, London, 1982.

2) Andrea Branzi, *The Hot House*, London, 1984.

3) Bart Lootsma, *Bataille*, in: Hein Eberson et al. (ed.), *Atelier van Lieshout, A Manual/Ein Handbuch*, Cologne, Rotterdam, Ostfildern, 1997; second impression, Rotterdam, 1998.

4) Bart Lootsma, *Joep van Lieshout, objecten, beelden of gewoon meubels?* Items 37, volume 10, April 1991. Partly as a result of this article several members of the editorial board resigned.

5) Ulrich Beck, *The Reinvention of Politics: Towards a Theory of Reflexive Modernization*, in: Ulrich Beck, Anthony Giddens, Scott Lash, *Reflexive Modernization, Politics, tradition and aesthetics in the modern social order*, Cambridge/Oxford, 1994.

6) Anthony Giddens, *The Constitution of Society*, Berkeley and Los Angeles, 1984.

7) Bart Lootsma, *Skulls, Urges I, Thanathos*, in: *Atelier van Lieshout, A Manual/Ein Handbuch*, see note 3.

8) Anthony Giddens, *Living in a Post-Traditional Society*, see note 5.

9) Anthony Giddens, *The Transformation of Intimacy,* Cambridge, 1992.

10) NL.Architects, *De Intraferie*, in: Hans Venhuizen (ed), *De Kunst van het Vestigen*; Bernard Hulsman, *Het Wilde Wonen, Carel Weeber wil af van het rijtjeshuis*, in: NRC Handelsblad, 04-04-1997, Cultural Supplement, page 1; Adriaan Geuze/West 8 Landscape Architects, *90.000 pakjes margarine, 100 meter vooruit! West 8 over landschap in acceleratie*, exhibition catalogue Groninger Museum, Groningen, 1997; Office for Metropolitan Architecture/NYFER, MAA$VLAKTE, The Hague, 1997.

BIOGRAPHIES

Prof.dr. Peter Hoefnagels (Bilthoven,1927) studied law and psychology, was involved in juvenile and criminal law, specialized at the University of California (Berkeley) and in 1965 was appointed to the Erasmus University in Rotterdam, where he was professor of criminology and family and juvenile justice until 1993.

Since 1974 he has developed a method of divorce arbitration, allowing people to divorce in a just and appropriate way. His method is based on an analysis of marriage as a relation and as an institution. In his opinion the traditional divorce method is like a declaration of war "but it ought to be a declaration of peace".

Hoefnagels has written books on marriage and divorce and criminology. He also writes novels, poetry and essays. He has been involved in architecture for many years and has studied the effect of the built environment on human behaviour. In 1974 at the World Congress of the *Federation for Housing and Planning* in Vienna he gave a lecture entitled 'Human measures and living, an interactional approach'. As social security advisor to city council of The Hague, among other things, he was involved in the design of the city's new town hall. From 1987 to 1995 he was a member of the Upper House of Dutch Parliament.

The last few years he has sung with the French Gypsie Swing Quartet 'Coco Brival', whose CDs include '*Grand Standards of Jazz*', issued in 1998.

Hoefnagels publications include: '*De Vulkaan*', short story, Uitgeverij De Prom, Baarn, 1987. '*De onbekende bevrijding*', novel, Uitgeverij L.J. Veen, Amsterdam, 1995. '*Gelukkig getrouwd, gelukkig gescheiden: een wegwijzer voor scheiden in goed overleg*', Uitgeverij L.J. Veen, Amsterdam, first published

1995, reprinted 1997. '*Dansen op het terras*', novel, Uitgeverij L.J. Veen, Amsterdam, first published 1997, reprinted 1998.

Ir. Bart Lootsma (Amsterdam, 1957) is a historian, critic and curator in the fields of architecture, design and the visual arts. He took his degree in Architectural History and Theory from the Eindhoven University of Technology (The Netherlands) with a reconstruction of the 'Poème Électronique', the Philips pavilion on the 1958 Brussels World Fair, designed by Le Corbusier, Xenakis and Varèse. Together with the architectural historian Mariëtte van Stralen he founded V.O.F. Boiling Phenomena.
Bart Lootsma was an editor of 'de Architect' and of 'Forum', currently he is a member of the editorial board of 'ARCHIS', of the Yearbook Architecturre in the Netherlands and Herausgeber of the Berlin-based magazine 'Daidalos' and contributes regularly to 'l'Architecture d'Aujourd'hui' and 'DOMUS'. He was an assistant-professor and lecturer at the 'Meister-klasse für Visuelle Gestaltung' at the 'Hochschule für Künstlerische und Industrielle Gestaltung' in Linz (Austria), head of the department of 3D-design at the Academy of Arts in Arnhem and lecturer at the Eindhoven University of Technology. He lectured and taught at the Academies of Architecture of Amsterdam, Rotterdam, Tilburg and Arnhem.
Currently he is a guest-professor at the Berlage Institute (Thesis Work) and lecturing at the PAS, both postgraduate courses in Amsterdam. Bart Lootsma published numerous articles and several books and catalogues on architecture, design and the visual arts. He was and is a member of several Dutch (semi-) governmental and municipal committees and juries dealing with architecture, design and

the visual arts. He had shows of his own work (installations and photography) in Holland, Austria and the USA and (co-) curated exhibitions for, among others, the University of Technology in Eindhoven, the Badischer Kunstverein in Karlsruhe, the Centre Georges Pompidou in Paris and the Kunsthalle in Vienna.

Drs. Menno Noordervliet (Doetinchem,1946) studied social psychology and pedagogy at the University of Amsterdam. He went on to study Rogerian psychotherapy at postgraduate level and spent ten years working in different crisis centres in Amsterdam and Hilversum.

He was director of the 'Centrum voor Zelfbezinning' (centre for self-reflection) in Utrecht for fourteen years, focusing particularly on the psychiatrist C.J. Schuurman and Carl Jung's work on depth psychology. He published regularly in the centre's own magazine 'Sfinx' on this subject. He is currently director of the holistic health centre 'De Nieuwe Vaart' in Hilversum.

As a student he became interested in astrology as a means of understanding and counselling himself and others. Like Schuurman and Jung he considers astrology helpful in making depth psychological portraits and interpretations.

As an astrologer he gives private consultations, as well as forming part of a consultancy team working with managers training at the 'Management Centrum de Ark' in Loosdrecht.

COLOPHON

Atelier van Lieshout
Roy Aerts
A.D.
Joop Hoekstra
Herman de Jongh
Joep van Lieshout
Marcus Müller
Frank van Ooijen
Jay Papik
Rian van Rijsbergen
Yolanda Witlox and others

printing
SSP, Amsterdam

design
Hein Eberson Trademark™,
Amsterdam

photography
Alain Alquier
Riccardo Bianchi
Peter Cox
Glenn Halvorson
Atelier van Lieshout
Derk-Jan Wooldrik

illustrations
Joep van Lieshout
Yolanda Witlox

editing
Hein Eberson
Joep van Lieshout
Rian van Rijsbergen

texts
BelBin Associates
Prof. dr. Peter J. Hoefnagels
Ir. Bart O. Lootsma
Drs. Menno J. Noordervliet

translation
Nicoline Gatehouse

final editing/organization
Rian van Rijsbergen

publishers
NAi Publishers
in collaboration with
Atelier van Lieshout
Rotterdam

This publication accompanies the exhibitions 'The Good, The Bad & The Ugly' in Rabastens (Tarn) 5 to 8 June 1998 and Le Parvis, Ibos (Hautes Pyrénées) 17 July to 12 September 1998 France and in the Migros Museum für Gegenwartskunst Zürich 1 April to 30 May 1999 Switzerland.

With special thanks to
Ministère de la Culture et de la
Communication, Direction
Régionale des Affaires Cul-
turelles de Midi-Pyrénées
Conseil Régional Midi-Pyrénées
Julien Andres
Gérard Baïsse
Nigel Belbin
Marc Bélit
Wolfgang Bergander
David Caméo
Thierry Carsenac
Didier Deschamps
Jeanne Ettori
Daniel Frossard
Sylvie Froux
Kathy Halbreich
Peter Lancaster
Gio Marconi
Alain Mousseigne
Bob van Orsouw
Roger Pailhas
Pascal Pique
Bernard Raynaud
Rolf Ricke
Grahame Robb
Jack Tilton
Marc Vaudey

Philippe Vergne
Walker Art Center
Fons Welters
Rein Wolfs

les Abattoirs

«migros museum»
Museum für Gegenwartskunst Zürich

ISBN 90-5662-102-5

Available in the United Kingdom and Southern Ireland through
Art Data, 12 Bell Industrial Estate, 50 Cunnington Street, Lon-
don W4 5HB, tel. 0181-747 1061, fax 0181-742 2319

Available in North, South and Central America through
D.A.P./Distributed Art Publishers Inc, 155 Sixth Avenue 2nd
Floor, New York, NY 10013-1507, Tel. 212 627.1999 Fax 212
627.9484

Atelier van Lieshout
Keileweg 26
NL-3029 BT Rotterdam
Tel: +31 10 2440971
Fax: +31 10 2440972